The South
By Its Photographers

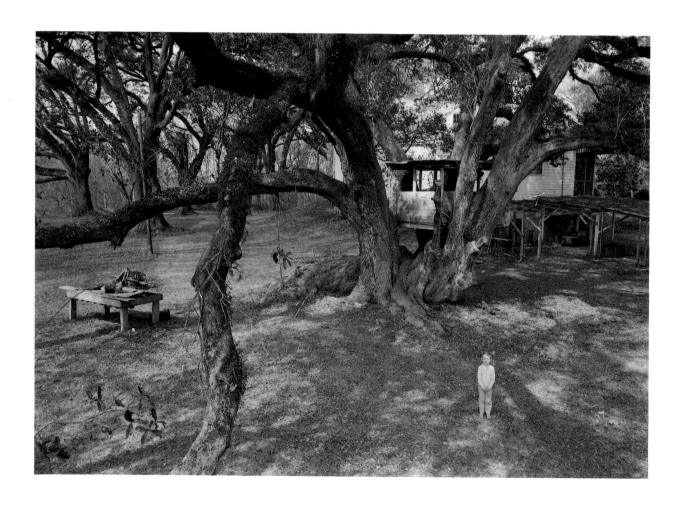

The South
By Its Photographers

Birmingham Museum of Art
Distributed by University Press of Mississippi

The South By Its Photographers

Birmingham Museum of Art
Birmingham, Alabama
October 20–December 29, 1996

Columbia Museum of Art
Columbia, South Carolina
January 24–April 6, 1997

The South by Its Photographers
Birmingham Museum of Art

Distributed by
University Press of Mississippi
3825 Ridgewood Road
Jackson, Mississippi 39211-6492
1-800-737-7788

Library of Congress Cataloging-in-Publication Data

The South by its photographers
 p. cm.
 "Birmingham Museum of Art, Birmingham, Alabama, October 20–December 29, 1996; Columbia Museum of Art, Columbia, South Carolina, January–April 1997."
 ISBN 0-87805-954-7
 1. Southern States—Pictorial works—Exhibitions. 2. Photography, Artistic—Exhibitions. I. Birmingham Museum of Art (Birmingham, Ala.) II. Columbia Museum of Art (1988)
F210.S675 1996 96-38440
779' .9975043'07476181—dc20 CIP

ISBN 0-87805-954-7

Cover: Jack Spencer, *Baptismal Candidates,* 1995. Sepia toned gelatin silver print, 14¼ x 14¼.
Frontispiece: Thomas Neff, *Amy Deanna Gant, Old Mound House, Maringouin, Louisiana,* 1987. Selenium toned gelatin silver print, 20 x 24.
Contents page: Mary Noble Ours, *B. J. with Horse,* 1994. Toned gelatin silver print, 15 x 15. Courtesy of Hemphill Fine Arts.

The South by Its Photographers has been organized by the Birmingham Museum of Art with additional support from *Southern Accents* magazine.
Funding is provided, in part, by the Alabama State Council on the Arts, the City of Birmingham, and *The Birmingham News/Birmingham Post-Herald.*

Excerpt from "Good Country People" in *A Good Man Is Hard to Find and Other Stories,* copyright 1955 by Flannery O'Connor and renewed 1983 by Regina O'Connor, reprinted by permission of Harcourt Brace & Company.

The editor for this catalogue was Susan Sipple Elliott. It was designed by Joan Kennedy and copy was edited by Brenda Kolb. The type is Schneidler Light with heads in Arkona. Electronic files were output by DPS, Inc. The book was printed by Craftsman Printing, Inc., on Vintage Velvet text with Reflections gloss cover.

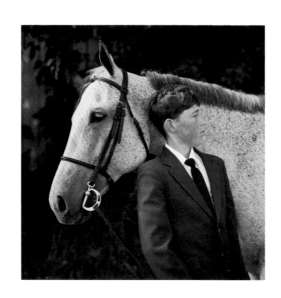

Contents

Photography taught me . . . that every feeling waits upon a gesture, and I had to be prepared to recognize this moment when I saw it. These are the things a story writer needs to know.

—Eudora Welty

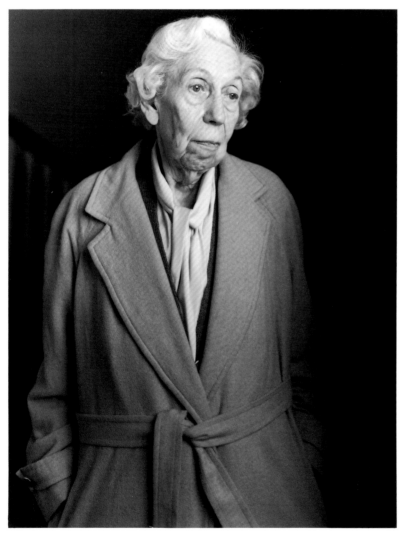

Curt Richter, Eudora Welty, *1989. Platinum/palladium print, 8 x 10.*

Acknowledgments

I wish to thank the forty-eight Southern photographers who have made this exhibition a reality. *Southern Accents* magazine was very involved with the initial stages of this exhibition, and I thank Katherine Pearson, then Vice-President and Editorial Director of *Southern Accents* and now of *Coastal Living* magazine, Frances M. MacDougall, Art and Antiques Editor, and Joe Watts, a former intern, for their assistance. I am indebted to our three jurors: Ellen Dugan, Curator of Photography at The High Museum of Art; Alex Harris, Editor, *DoubleTake* magazine and Professor of Documentary Studies at Duke University; and Philip A. Morris, Editor-at-Large, Southern Progress Corporation.

The Columbia Museum of Art, South Carolina, will host *The South by Its Photographers* from January 24 through April 6, 1997, and I wish to acknowledge William B. Bodine, Jr., Chief Curator, and Salvatore G. Cilella, Jr., Diector and C.E.O., for all of their efforts. Special thanks to Dr. Thomas Johnson of the South Caroliniana Library at the University of South Carolina for his help in researching Southern authors and selecting some of the quotes in this catalogue and exhibition.

Finally, I am most grateful to my colleagues at the Birmingham Museum of Art for their enthusiasm and interest in this exhibition, particularly Dr. John E. Schloder, Director; Suzanne Voce Stephens, Exhibitions Coordinator; Joan Kennedy, Head of Publications; Dr. Kate Bennett, Curator of Education; Suzan Harris Russell, Assistant Curator of Education; Terry Beckham, Exhibition Designer, and his preparatory staff; Frances Caldwell, Public Information Officer; and my outstanding interns, Amy Curry and Anil Mujumdar.

Susan Sipple Elliott
Curator, The South by Its Photographers
Birmingham Museum of Art

Nobody in my school loved where they lived. Most of the students were either black kids or doctors' kids. They lived in shacks or they lived in executive homes, but they all wanted one thing: to be someplace else. I traced their unhappiness and antisocial behavior down to that one central trouble, geographic restlessness. It was what caused them to smoke marijuana and throw trash from cars. Home was exactly the place where they did not want to be. Greyhound, I thought, could cure the drug abuse problem overnight by giving out passes.

–Josephine Humphreys, Rich in Love

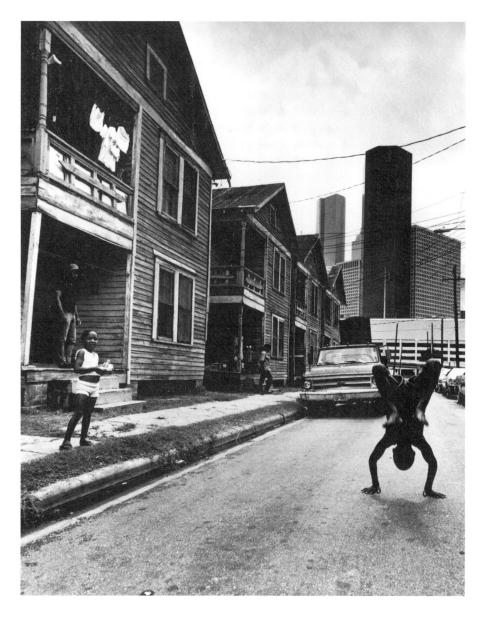

Earlie Hudnall, Jr.,
Flipping Boy, *1986.*
Gelatin silver print,
16 x 20.

Introduction

Tell about the South. What's it like there. What do they do there. Why do they live there. Why do they live at all.

—*William Faulkner*, Absalom, Absalom!

The idea for this exhibition began with a conversation between the staff of *Southern Accents* magazine and the staff of the Birmingham Museum of Art. *Southern Accents* wished to foster a greater understanding of contemporary photography and an interest in collecting it. The Museum, with its growing collection of photographs and its continuing focus on Southern artists, wanted to combine these two by highlighting the work of Southern photographers. The results of this collaboration are represented on the walls of the Birmingham Museum of Art and in the pages of this catalogue.

The exhibition takes a look at the South and how it is portrayed by Southern photographers. A rich and diverse selection of images was obtained from artists who were born in the South, currently live here, or have done a significant body of their work here. Names of photographers were solicited from museum curators, gallery owners, and collectors from Texas to Washington, D.C. The nominated artists were then asked to choose five slides of their work to be juried. The entries were reviewed by a panel consisting of Ellen Dugan, Alex Harris, and Philip Morris. We owe them a debt of gratitude for their dedication, diligence, and critical acumen in selecting the photographs for this exhibition.

These works provide a portrait of the South today; all were taken within the past ten years and therefore are an extraordinary reportage on the "new" South. Many viewers will be challenged by what they see, for along with the familiar there is the startlingly unfamiliar. Images that a few decades ago would not have been considered "Southern" are now displayed. Alongside the photographs of genteel matriarchs and Bubbas are those of *señoritas* and *fatmas*. Along with majestic panoramas are scenes of urban blight. Here are haunting images of bygone splendor—sometimes romaticized, sometimes in tatters—and reflections of memories, of hope, of despair. The artists deal with issues of their times: AIDS, the environment, cultural clichés, unresolved racial questions. These photographs will help all of us to see more and to see differently, to explore areas of which we may have been previously unaware. These discoveries will help us to better understand the diversity of the cultures that make up the South today, so that we may live with a little more harmony, with a little less ignorance, prejudice, or hatred.

Overall, one is struck by the sheer beauty of the photographs. Each one, in addition to the stories it tells, is a powerful work of art. Together they capture a sense of place—sometimes familiar, sometimes not—and a sense of time.

If some of the photographs seem to show Anywhere, U.S.A., this is because the great homogenization of American life is an important element of the New South. But in spite of this Americanization of Dixie—or

the Southernization of other parts of the country—the South remains the most distinctive region in the nation. What novelist and critic Stark Young said decades ago still applies: "The South changing must be the South still."[1] As a recent transplant to the South, having lived most of my life in the East and Midwest, I can attest to the persistence of a Southern distinctiveness. In the South one observes the continuing tendency to place more emphasis on the land and place, on family and community, on tradition and myth and history, on religious beliefs and practices. These continuing values have been beautifully captured by the photographers in this exhibition.

Just as the land and lives of the South have fascinated generations of photographers, they have also stirred the souls of writers. Some of the greatest literature of this century was written by Southerners. Several of the photographers in this show recognize, in the statements accompanying their photographs, the influence of literature on their work. We have chosen, therefore, to present alongside the photographs in the exhibition, and to a lesser degree those in the catalogue, quotations drawn from authors (mostly contemporary Southern novelists and storytellers, poets, essayists, or journalists) who share with the photographers particular themes, characterizations, a spiritual vision, or a cultural identity. Together the images and the words present those elements which, according to literary editor Shannon Ravenel, still characterize the Southern experience: a strong narrative voice; a resilient sense of humor, even in the face of tragedy; deep involvement in place, family bonds, and local traditions; a sense of impending loss; celebration of eccentricity; racial guilt and human endurance."[2] Both photographs and writings reflect those "signs of the real South, the good South," as identified by journalist John Egerton: "human comedy and drama, words and music, food and drink, manners and rituals, kin and friends, birth and marriage, death and burial."[3]

This exhibition extends and underscores the Birmingham Museum of Art's commitment to regional contemporary art, which began with the Museum's founding in 1950 by a committee of the Birmingham Art Association. This commitment continued over the years in a series of *Focus* exhibitions highlighting Alabama artists and with *Looking South: A Different Dixie* (1988). In 1994 the Museum presented *Made in Alabama*, a highly acclaimed traveling exhibition and catalogue, the result of a ten-year research project tracing the history of artists in Alabama in the nineteenth century. Most recently we organized *Pictured in My Mind*, a look at contemporary self-taught artists from across the United States, which was especially rich in Southern artists. This commitment will continue in 1997 with *Southern Arts and Crafts: 1890–1940. The South by Its Photographers*, however, is our first major traveling exhibition devoted exclusively to Southern photographers. We are pleased to bring their superb works to a greater audience.

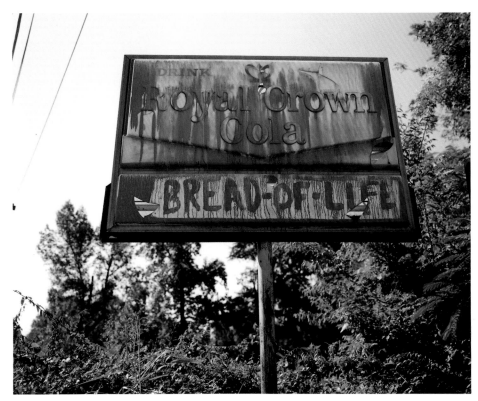

William Christenberry, Bread-of-Life, Near Tuscaloosa, Alabama, *1989. EK 74 print, 20 x 24. Loan from the artist and Pace Wildenstein MacGill Gallery, New York.*

This exhibition could not have been accomplished without the hard work of a great number of people, many of whom are recognized in the Acknowledgments. I want to mention here Susan Sipple Elliott, who did the lion's share of the work, from the initial correspondence with gallery owners and artists to the overseeing of the production of this catalogue. Her enthusiasm and diligence have brought this important show and catalogue to fruition.

This catalogue is dedicated to the outstanding artists who are represented in the exhibition. They have done a magnificent job of capturing a complex image of the South for our enjoyment, enrichment, and enlightenment.

Dr. John E. Schloder
Director

Notes
1. Stark Young, *I'll Take My Stand* (New York: Harper and Brothers, 1930), 359.
2. Shannon Ravenel (ed.), *New Stories from the South: The Year's Best* (Chapel Hill, North Carolina: Algonquin Books, 1990), vii–ix.
3. Bill Weems, *South,* text by John Egerton (Portland, Oregon: Graphic Arts Center, 1987), 100.

It is utterly exhausting being Black in America—physically, mentally, and emotionally. While many minority groups and women feel similar stress, there is no respite or escape from your badge of color. The daily stress of nonstop racial mindfulness and dealings with too many self-centered people who expect you to be cultural and racial translators and yet feel neither the need nor responsibility to reciprocate—to see or hear you as a human being rather then just as a Black or a woman or a Jew—is wearing.
—*Marian Wright Edelman,* The Measure of Our Success

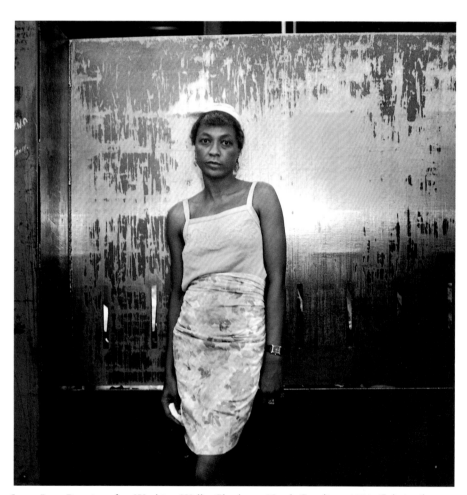

Susan Page, Beatrice after Washing Walls, Charlotte, North Carolina, *1995. Gelatin silver print, 16 x 20.*

Statements of the Jurors

The artists in this catalogue represent a wide range of ages, backgrounds, and perspectives. However, all are united by what the eminent curator John Szarkowski called "the ancient impulse of the artist to find his own unoccupied ground." The ground that Szarkowski refers to is, of course, the quest of each individual artist to find new artistic ground, to locate his or her own singular expressiveness. But in the context of this exhibition, the ground also refers both literally and metaphorically to the land, people, culture, and history of the American South. A region that is and has always been made up of many places and peoples and yet remains, even in the late 1990s, singularly one place—a place of social and political contradictions and complexities; a place of traditions, strength, and grace; a place indelibly marked by a "peculiar" history that still powerfully resonates and affects contemporary life. From this rich amalgam of reality and myth, these artists have drawn a wealth of inspiration and produced important, provocative work that is insistently rooted in the Southern past (to one degree or another) and yet seeks to redefine and rethink Southern identity and the art of photography itself, at the end of a century of great change.

Ellen Dugan
Curator of Photography
The High Museum of Art

In making the selections for this exhibit, Ellen Dugan and I were looking for more than great photographs. We were searching for authentic images by photographers who, with only a few examples of their submitted work, were able to show a distinctively personal vision of the South. We wanted to choose photographers who could look beyond both the old and the new Southern symbols.

I believe we found photographers who could help us all to know this region, in part because they made pictures of the South they have actually lived, and felt, and finally seen. We hope that the combination of these photographs—in most cases several images by each photographer—will produce a portrait of the South that is richer than any individual photographer could have made and that is more complicated and revealing than anything we could ever say about this region.

Alex Harris
Editor, DoubleTake
Professor of Documentary Studies, Duke University

I have spent much of my career assessing photographs intended to illustrate specific subject matter. To review the work of a diverse group of photographers responding to anything in the region today that inspires them, and to know that the photograph itself is the subject, was for me rather a wild ride.

An editor wants to pull out meaning and theme. I was struck by the recurrence of portraiture in the selected images—unpredictable and often eccentric, but still with a controlling formality. At the same time, there is a seeming artlessness and even lack of control evident in many of the photographs. It energizes them but contradicts what I, and I think many others who don't follow the field closely, might expect from photographic art.

There are some serene and sweeping moments, but for me the exhibit walks right in the South's door, sits down, and gets personal.

Philip A. Morris
Editor-at-Large
Southern Progress Corporation

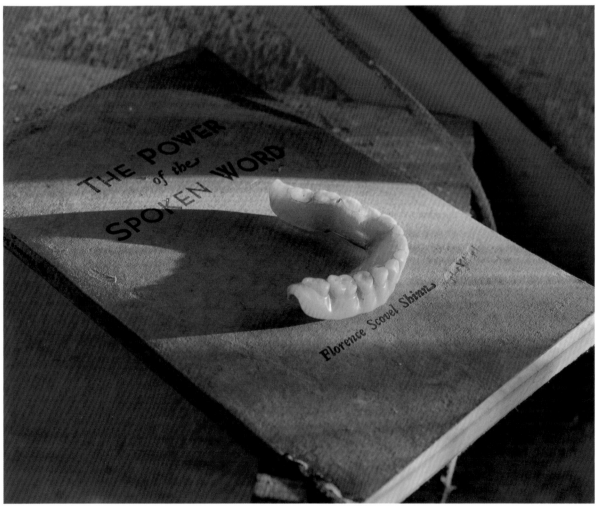

Birney Imes, untitled, 1995. Color coupler print, 16 x 20.

Catalogue

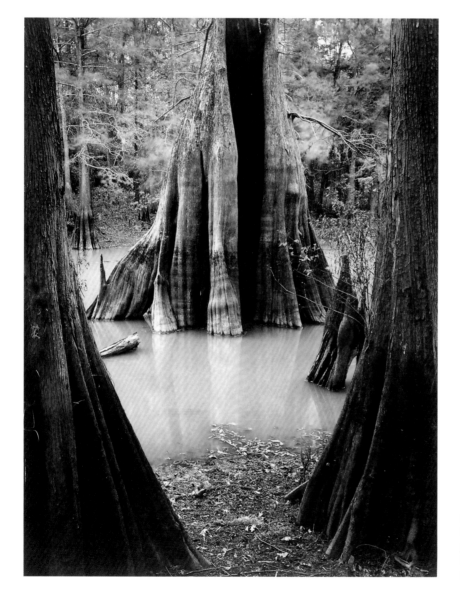

Richard C. Albertine, Giant
Cypress, *1990. Toned and gilded
gelatin silver print, 11 x 14.
Courtesy of Michael Shapiro
Gallery, San Francisco.*

List of the Artists

Photographs illustrated in the catalogue section are listed first in the checklist of each artist. Measurements are given in inches by sheet size, height preceeds width.

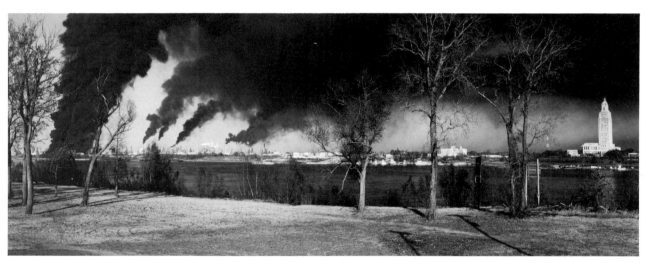

A. J. Meek, Exxon Fire and Explosion, *1989. Gelatin silver print, 8 x 20.*

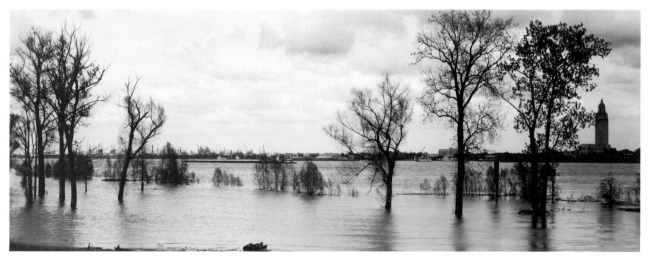

A. J. Meek, Mississippi River Flood, Baton Rouge, *1989. Gelatin silver print, 8 x 20.*

Color Photographs

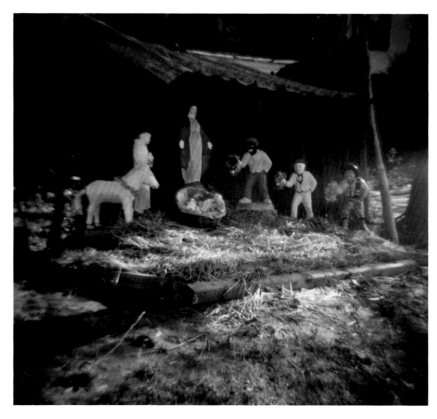

Amy Blakemore

Nativity Scene

1987
Color coupler print
15 x 15
Loan from the artist
and Inman Gallery,
Houston

Born October 24, 1958, in Tulsa, Oklahoma.
Lives in Houston, Texas.
Education: BA, Drury College; BS, Drury College; MFA, University of Texas at Austin.
Selected recent exhibitions: *Amy Blakemore*, Relay Zone Gallery, Kansas City Art Institute, Kansas
 City, Missouri, 1995; *Texas Art Celebration '95*, Houston, Texas, curated by Marti Mayo, 1995; *The Big
 Show*, Lawndale Art and Performance Space, Houston, Texas, curated by Tom Moody.
Selected honors, awards, grants: The Glassell School of Art Travel Grant, 1991 and 1993; Dozier Travel
 Award, Dallas Museum of Art, 1992; Creative Artist Award, Cultural Arts Council of Houston, 1989;
 Anne Giles Kimbrough Fund, Awards to Artists, Dallas Museum of Art, 1987; Graduate Research Grant,
 University of Texas, 1983.

I think I quit being embarrassed about being from the South when I met a large number of people from
the Northeast after I graduated from college. They experienced a great deal of shock when they moved here.
I was a bit envious of their culture shock because I didn't really understand or experience what they were
always talking about. I remember one woman being horrified at the thought that people actually ate catfish.
I remembered that when I was a child having fried catfish was kind of a big deal after church on Sundays.
They had never eaten grits or fried okra or gone target shooting or tromping through cow pastures. They had
never seen lightning bugs or heard cicadas. I realize that this is perhaps an idealized and bucolic or maybe
even a clichéd version of the South. There are things about the South that aren't so nice but being Southern-
ers we don't really talk about such things.

These photographs were taken about the time that I decided that being from and living in the South
was a pretty great thing. They are about the affection I feel for my hometown of Tulsa specifically, and the
South in general. I am giddy and laugh every time I see Oral Roberts' sixty-foot hands or when I remember
the petition drive to paint pants on the Oilman at the fairground because someone deemed the monument
obscene. I recall the year I spent at Nathan Hale High School which seemed more like a prison than a school.
I love the incredible winter light and how weird the South and its people are. It's all just a little bit off.

—Amy Blakemore

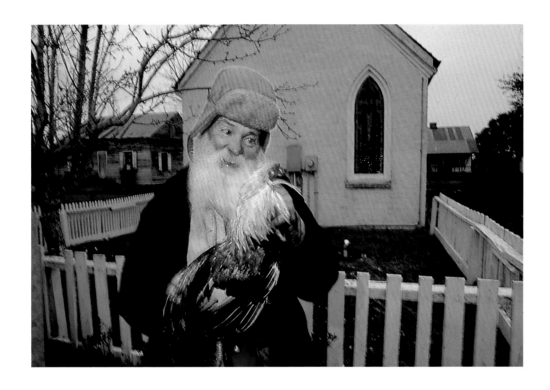

Syndey Byrd

Chicken Man, from Courir du Mardi Gras series
1986
Color coupler print
16 x 20

Bug on a Horse, from Courir du Mardi Gras series
1989
Color coupler print
16 x 20

Born in 1944 in Hattiesburg, Mississippi.
Lives in New Orleans, Louisiana.
Education: Fine Arts, University of Mississippi.
Selected recent exhibitions: *Bon Temps Rouler: The Culture of Louisiana's Carnival*, Southern Arts
 Federation, 1991–93.
Selected honors, awards, grants: Silver medal, Adda competition, New Orleans Tourist Commission, 1993;
 Purchase Prize, New Orleans Photographic Biennial, 1988.

What makes my photographs "typically Southern" is asked for me to describe my photographs of south
Louisiana. Alas, they are "Southern," but in my realm of photography nothing is "typical"! Everyday reality
borders on surreal, as well as the once-a-year fantasies of my Mardi Gras images.
 The "chicken man" of Lafayette, Louisiana, cradles a typical offering for the "Mardi Gras" of Cajun
Country with gleaming eyes that say "Um, Gumbo!" There is so much here that does not exist anywhere else
in the world, and it has been my pleasure to document the uniqueness that is Louisiana for more than
twenty years.

–Syndey Byrd

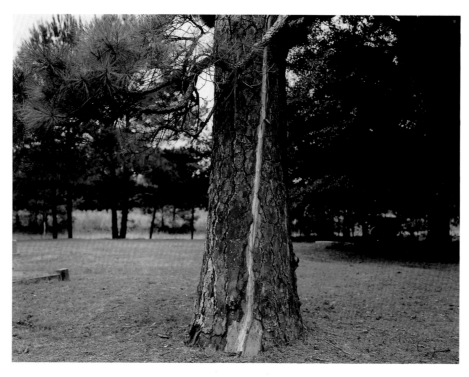

William Christenberry
Pine Tree Struck by Lightning, Stewart, Alabama

1987
EK 74 print
20 x 24
Loan from the artist and Pace Wildenstein MacGill Gallery, New York

Bread-of-Life, Near Tuscaloosa, Alabama

1989
EK 74 print
20 x 24
Loan from the artist and Pace Wildenstein MacGill Gallery, New York
Reproduced on page 11

I cannot, will never deny Walker's influence on me. It was great. But it was Agee first. I had never run into a writer who described so clearly, so beautifully, the things I had experienced as a child. The smell of that landscape. Of course, the appearance of it. And, just the minute detail. The fact that he was a fellow Southerner made it even more important to me.

—William Christenberry on the influence of *Let Us Now Praise Famous Men*, by James Agee and Walker Evans, from *William Christenberry: The Early Years, 1954–1968,* by J. Richard Gruber

Born in 1936 in Tuscaloosa, Alabama.
Lives in Washington, D.C.
Education: BFA, University of Alabama; MA, University of Alabama.
Selected recent exhibitions: *William Christenberry: Drawing, Painting, Photography, and Sculpture,* Pace MacGill Gallery, New York, 1995; *Recent Work, William Christenberry,* Nancy Drysdale Gallery, Washington, D.C., 1994; *William Christenberry,* Southside Gallery, Oxford, Mississippi, 1994; *Of Time and Place: Walker Evans and William Christenberry,* Amon Carter Museum, Fort Worth, Texas, 1990.
Selected honors, awards, grants: Art Matters Grant, New York, 1994; Yale University Summer School of Art and Music, Visiting Artist (Painting), Norfolk, Connecticut, 1991 and 1993.

Photography has always been a part of my artistic activity, which also includes painting and sculpture. I use these media to express the many concerns and feelings in my life and also about my background. It is the relationship of all of these means of expression and their totality that best exemplify my work.

—William Christenberry

Maude Schuyler Clay

Emma and Schuyler, Sumner, Mississippi
1992
Color coupler print
16 x 20

The Christmas Story, Sumner, Mississippi
1992
Color coupler print
16 x 20

Born in 1953 in Greenwood, Mississippi.
Lives in Sumner, Mississippi.
Education: University of Mississippi; Memphis Academy of Arts.
Selected recent exhibitions: *Animal Attractions*, Howard Greenberg Gallery, New York, 1995; *Maude Schuyler Clay: New Photographs*, Southside Gallery, Oxford, Mississippi, 1994; Los Angeles Museum of Art, 1993; *The Terrors and Pleasures of Domestic Comfort*, Museum of Modern Art, 1991.
Selected honors, awards, grants: Nominee, Governor's Award for Excellence in the Arts, 1993; Mississippi Arts and Letters Award for Photography, 1988 and 1992.

The main reason I began taking pictures was to try and tell a story. Though most of my photographs have been made in the South, the stories have not necessarily always been Southern ones. This visual method of storytelling, coupled with a desire to keep an accurate record of things, does give my chosen subject matter a kind of history, much of it undeniably Southern. I have not, however, intentionally set out to make a specific record of the South.

Establishing an intimacy with my subjects is important; yet to be able to take good pictures, a photographer—who is, after all, a kind of voyeur—needs to maintain a kind of distance. For me, photography fulfills the complex and inexplicable combination of exploring both the subjective and the objective.

Specifically, the photograph of Emma and Schuyler was taken on Christmas Day in Mississippi, and it is one in which my role was a dual one: that of a mother witnessing her baby son's distress, and that of the opportunistic photographer getting the shot anyway. Perhaps the most remarkable thing about the picture to me is the fact that Emma was there to stand in for me the mother, while I was being me the photographer.

—Maude Schuyler Clay

Elm Bluff was a large plantation with about two hundred slaves. The house must have been a big one, because my great-uncle entertained many of his friends and neighbors there. As he had no wife, he used to bring down from the North a "lady housekeeper," so called, who presided and acted as hostess.

In those days travel was almost entirely by the river steamers, which had a habit of running on mudbanks and being delayed for a day or two at a time. Gentlemen from the plantations for many miles around used to ride to Elm Bluff and settle down with my great-uncle to stay for as long as might be necessary, until their steamer came along the river and carried them on down to Mobile. In the big house at Elm Bluff, my mother told me, there was a large library, and there, laid out on a long table, were American periodicals and many European ones. I like to know this and to realize that the people who lived in Alabama in those long-ago days were not cut off from the world.

—Recollections of Virginia Crocheron Guildersleeve, great-niece of Elm Bluff's builder, John Jay Crocheron, from *Silent in the Land,* by Harry Knopke

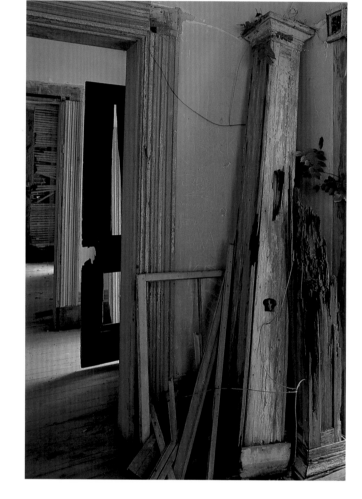

Chip Cooper
Column–Elm Bluff

1993
Cibachrome print
13½ x 20

Born in 1949 in Savannah, Georgia.
Lives in Tuscaloosa, Alabama.
Education: BA, University of Alabama, 1972; postgraduate work in photography, University of Alabama Art Department, 1972–73.
Selected recent exhibitions: *On Common Ground*, one-man exhibition, Huntsville Museum of Art, 1995; *Alabama Impact: Contemporary Artists with Alabama Ties*, Mobile Museum of Art and Huntsville Museum of Art, 1995.
Selected honors, awards, grants: Award of Excellence, Book Series 1994, *Communication Arts* magazine; over ten awards through University Press Photographers Association (UPPA); twenty-five ADDYs from Birmingham and Tuscaloosa ad clubs.

The southern landscape was one inhabited by people who considered the architecture of their homes to be in harmony with their surroundings. The people who lived here—their pleasures and their sufferings and their day-to-day rhythms—are in many cases long forgotten.

These images represent what is left in a vanishing landscape.

–Chip Cooper

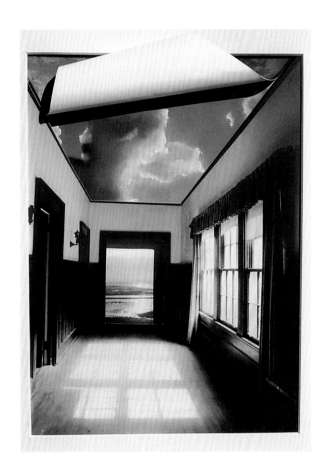

Paula Eubanks
Island Hall

1990
Hand-colored photo collage
12 x 9 x 2

Born in 1948 in Macon, Georgia.
Lives in Cedar Falls, Iowa.
Education: BFA, University of Georgia, 1970; MFA, University of Georgia, 1972; Ed.D., University of Georgia, 1995.
Selected recent exhibitions: *Straight Shots*, NationsBank, Atlanta, Georgia, 1994; *Current Views*, Georgia Places, Brenau University, Gainesville, Georgia, 1995.
Selected honors, awards, grants: Georgia Sea Grant, 1991–92; Best in Show Award, Quinlan Art Center Exhibit, Gainesville, Georgia, 1991; Georgia Council for the Arts artist-initiated grant, 1988.

The South is old, lovely, gracious, warm, and complicated, with layers of meaning and stories left to be discovered. My images reflect these same qualities in both subject matter and medium. All of these are hand-colored silver prints. The photographs are archivally printed on matte surface paper, then colored with a combination of oil paint and colored pencils. I chose this medium because I can control the color, keeping it subtle and making subjective choices laden with meaning. Hand-colored photographs are a medium based in the past and therefore are particularly appropriate for my work, which is often based on architectural forms from the past complete with the historical research that surrounds them.

This piece is three-dimensional and some parts advance or recede physically in space. Some of my pieces require the use of deep frames, like shadow boxes, while my smaller pieces can fit in Neilsen deep metal frames. This physical depth alludes to the layers of meaning in the work and engages the viewer, encouraging movement around the work to peer into the spaces of the piece.

The subject matter is most often a combination of architecture and nature. The openings inherent in doors and windows provide metaphors for points of transition. If the house is a metaphor for the soul, then the soul of the South is surely represented by these lovely, old, and gracious mansions. Landscapes, sea-scapes, sunrises, and sunsets all take on spiritual significance. Several reviewers have interpreted the work as having religious significance.

Island Hall was shot in a haunted house on Cumberland Island. The ceiling in the hallway is crumbling and peels back to reveal the sky. The South is so gothic, full of interesting stories about ghosts, and this piece has its own story, to be read in the image or told orally in the Southern tradition.

–*Paula Eubanks*

25

Peter Goin

Plastic orange fences mark "nature areas" that are to remain undisturbed during construction at the North Carolina Zoological Park near Asheboro, North Carolina
1991–92
Color coupler print
16 x 20

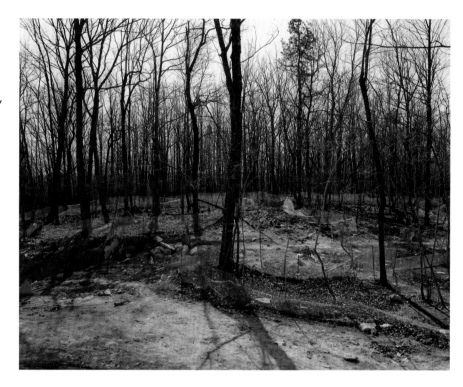

Born in 1951 in Wisconsin; lived there three months then moved to Fairfax, Virginia.
Lives in Reno, Nevada.
Education: Duke University.
Selected recent exhibitions: Solo exhibition, Clement Gallery, University of Toledo, Ohio, 1995; Solo
 Exhibition, New York Public Art Project: Transit Authority, 1995; *Ascent/Descent,* part of *Reverberations:
 Diptychs and Triptychs,* Southeast Museum of Photography, Daytona Beach, 1995.
Selected honors, awards, grants: Nevada Humanities Committee Research Grant, *The Illusion of Mining,* 1996;
 University of Nevada Board of Regents Creative Activities Award, 1996.

Today, wilderness is more a cultural idea than a physical reality. Nature is under siege as people shape every last inch of the global habitat. From creating savanna through fire to contaminating regional watersheds with industrial pollutants and radioactivity, to engineering new and radically different plants and animals, the forest primeval is now a human product. Even the definition of nature is a human product and reveals more about culture than about the web of life.

Most Americans still dream that nature is the same scene as what they think the seventeenth- and eighteenth-century explorers saw in the New World during the era of westward expansion. But we know this is not the case. The air we breathe is an industrial composite. Rainfall is a human product instead of the most basic source of life. Rivers and lakes are elements within a water-management system. Forests are manufactured and harvested like soybeans and corn. Animals are controlled, bred, and genetically designed. Insects are raised in massive numbers, then irradiated and released. Rocks are made "natural" by spraying cement onto wire forms and adding the right colors. Plants and trees are made from plastic. Beaches are reconstructed. Everywhere I look, nature is an illusion.

The idea of wilderness is part of the paradigm of Nature that has been created and maintained in order to realize cultural, economic, and spiritual goals. In our attempt to manipulate biotic communities for human purposes, we have forgotten "humanature." This photograph is part of a project that uses color photographs to document the pervasive control of "nature," using the sunbelt South as the focus of the study.

Humanature was recently published by The University of Texas Press.

–Peter Goin

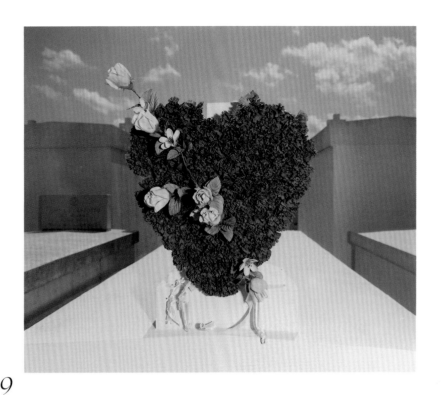

William K. Greiner

Blue Heart, Houma, Louisiana, 1989
1989
Color coupler print
30 x 26

Blue Guitar, Near Raceland, Louisiana, 1990
1990
Color coupler print
30 x 24

Born September 8, 1957, in New Orleans, Louisiana.
Lives in Metairie, Louisiana.
Education: AA, liberal studies, Bradford College, 1980; BFA, photography, Tufts University, 1982; MBA, finance, Suffolk University, 1985.
Selected recent exhibitions: Ithaca College, solo exhibition, New York, 1996; G. Gibson Gallery, solo exhibition, Seattle, Washington, 1995; Duke University, two-man exhibition, Durham, North Carolina, 1995; New Orleans Museum of Art, group show, New Orleans, 1995; Eva Cohon Gallery, solo exhibition, Chicago, 1995.
Selected honors, awards, grants: Visual Arts Prize, Suffolk University, Boston, Massachusetts, 1984.

The photographs represent a thing and place unto themselves. The color in the images is intended not to be gratuitous but to be an integral part of description and interpretation. Symbols and objects are to be read and interpreted. Telephone poles mimic crosses, the cobalt blue sky beckons us towards "heaven," deep shadows are an abyss, and white paint symbolizes purity or goodness. Floral Styrofoam hearts break in the wind, not unlike the hearts of a deceased's loved ones. Statuary act as guardians. Plastic flowers are brighter at first than the real thing—yet ultimately they too fade. An empty picture frame reminds us that someone or something is missing. Plastic flowers in plastic bags appear to suffocate in a humid fog. Red carpeting, which is laid down as though for some dignitary, is engulfed in grass, or winter-killed grass lends a golden backdrop evidencing its demise and alluding to its return in another season. Death and rejuvenation are inevitable.

The ornaments, fixtures, drawings, flowers, pictures, trinkets, and written words, I find, are the wonderful ways homage is paid or the existence of a loved one or friend is remembered. To this extent these images represent disintegration, rejuvenation, and life cycles. Additionally, they are documents of some of the ways, in our Southern culture, loved ones are remembered and eulogized. Viewing these images, we are left to provide our own fiction as to the circumstances of these things and places.

—William K. Greiner

Birney Imes

Untitled

1994
Color coupler print
16 x 20

Untitled

1995
Color coupler print
16 x 20
Reproduced on page 14

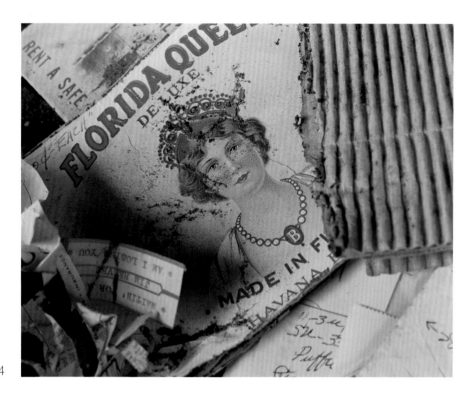

Born in 1951 in Columbus, Mississippi.
Lives in Columbus, Mississippi.
Education: BA, history, University of Tennessee, 1973.
Selected recent exhibitions: The World Financial Center, New York, 1995; Bonni Benrubi, New York, 1995;
 Gallery for Contemporary Photography, Santa Monica, 1994.
Selected honors, awards, grants: Mississippi Institute of Arts and Letters, Photography Award, 1995; National
 Endowment for the Arts, Individual Artist's Fellowship, 1988.

In the late 1940s, Blume C. Triplett built for his wife, Miss Eppie, a roadside restaurant and tavern which they named Whispering Pines. The two operated the place through the 1950s and '60s, serving the white customers driving up from neighboring Noxubee County and the mostly black clientele living in the surrounding community. Mississippi was segregated at the time, and they built the place with two sides to accommodate both sets of customers. As Eppie's health began to fail in the mid '60s, business slowed, and the place became a repository for Blume's stuff—old cars, pinball machines, jukeboxes, cigar boxes.

I first stumbled upon the Pines not long after I had begun photographing in the mid '70s. By then Eppie had died, the white side had filled with Blume's relics, and his creation had become hardly more than a neighborhood gathering place. For the next twenty years I visited, ate, drank, and occasionally photographed in and around the place, and in time, I too became part of Whispering Pines.

Blume died in 1991, nursed to the end by Rosie Jane Stevenson, a black woman who had come to work for Miss Eppie as a teenager and who had run the place for Blume for many years. Other than the exterior shell, not much is left of the Pines. The contents have been sold and most of the windows have been boarded over.

Today the only remnant of the lives that passed through the place is the crushed rubble littering the floors of its empty room. This is one of the photographs that came from that rubble.

—Birney Imes

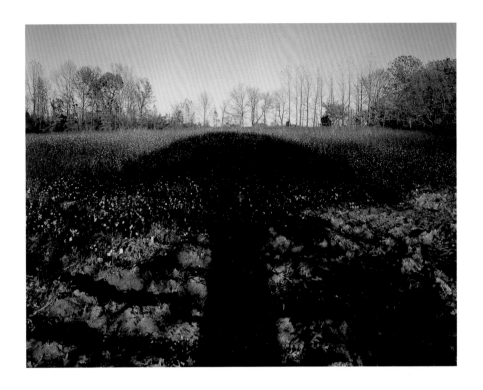

Larry E. McPherson
Tree Shadow off Pleasant Ridge, Shelby County
1992
Color coupler print
16 x 20

Born in 1943 in Newark, Ohio.
Lives in Memphis, Tennessee.
Education: BA, photography, Columbia College, 1976; MA, photography, Northern Illinois University, 1978.
Selected recent exhibitions: *Photowork '95*, D.C.A.A./Barrett House Galleries, Poughkeepsie, New York, 1995;
 The Brooks 1994 Biennial: Contemporary Memphis Photography, Memphis Brooks Museum of Art, Memphis,
 1994; *RePairing Photographs from the Permanent Collection*, New Orleans Museum of Art, New Orleans, 1994.
Selected honors, awards, grants: Tennessee Arts Commission Individual Artist Fellowship in Photography,
 1996; Guggenheim Fellowship in Photography, 1980; National Endowment for the Arts Grant-
 Fellowship in Photography, 1979 and 1975.

Landscape is the subject I turn to most often with passion. My current project began in 1991, when I set out to make landscapes in Memphis and the surrounding area. It is important to me to see and photograph the beauty present in the midst of where I actually live.

There is a nurturing energy coming through the land, through nature, which I want to honor in my photographs. And I can see that there are nuances of meaning and a subtle beauty in man's relationships with land. In this work I hope to deepen my understanding of this aspect of life and embrace it with affection. What makes these pictures "Southern" is that they are made in the soybean and cotton country of the South.

—Larry E. McPherson

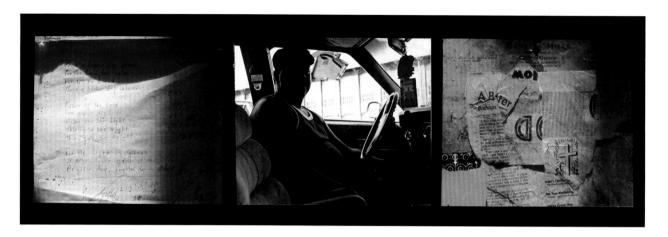

Phil Moody

Jesus

1994
Cibachrome prints
20 x 74

Mountains and Sea

1994
Cibachrome prints
24 x 83

Workers' Memorial

1995
Cibachrome and gelatin silver prints
74 x 62

The church in the South has always pointed out the relation of individual tragedies of Christian faith. The key words? "In the darkness comes the light." There is a cross at the heart of life. Love suffers, and dies, and is born again. Love continually creates life.
—James McBride Dabbs, Who Speaks for the South?

Born April 2, 1949, in Berwick-on-Tweed, England.
Lives in Rock Hill, South Carolina.
Education: Diploma of Art, Edinburgh College of Art, 1971; Certificate of Teaching in Art, 1973; MFA, University of Michigan, Ann Arbor, 1985.
Selected recent exhibitions: *Intersections on Seven Mile Road: Detroit 1984–1989*, University of South Carolina at Spartanburg, 1996; *Triennial '95 Selections*, Rudolph E. Lee Gallery, Clemson University, 1996; Texas exchange exhibition, Fife Institute, Glenrothes, Scotland, 1995; three-person show with Jorge Otero and Diane Hopkins Hughs, Hampton Gallery, Taylors, South Carolina, 1994.
Selected honors, awards, grants: Rock Hill Arts Council Small Project Grant, 1995; Winthrop University Faculty Research Grant, 1995; third place, Photospiva Exhibition, Joplin, Missouri, 1993.

South Carolina's relationship with the textile industry is historic and well documented. Readings from such works as Morland's *Millways of Kent* and Robertson's *Red Hills and Cotton* have been my guides since coming to this state nine years ago. In that time, I have photographed its people and towns, with a particular interest inside many of the small and older textile mills.

This new work comprises large color portraits superimposed or juxtaposed with supporting imagery (in color and black and white) gleaned from my own shooting or technical manuals I have found. Such imagery includes houses clustered around the mill which straddles the river at Lockhart, some of the once glorious interior mill spaces as at Lando, black and white machinery illustrations from the old glass plates, and women sorting colorful cut-offs to be bailed in Fort Mill. In some pieces "straight" portraits are flanked by text, some of which records the generation of families who have worked in the same mill.

—Phil Moody

Sonja Rieger

Night Lightning
1989
Cibachrome print
20 x 24

Night Puddle
1989
Cibachrome print
20 x 24

Born in 1953 in Ansbach, Germany.
Lives in Birmingham, Alabama.
Education: BA, art, University of Massachusetts, Amherst, 1976; MFA, sculpture, Rutgers University, 1979.
Selected recent exhibitions: *The Rena Selfe Collection of Photography*, Birmingham Museum of Art, Birmingham, Alabama, 1996; *Alabama Impact: Contemporary Artists with Alabama Ties*, Fine Arts Museum of the South, Mobile, Alabama, 1995; *Birmingham: Into the Night*, Blue Spiral Gallery, Asheville, North Carolina, 1994.
Selected honors, awards, grants: Faculty Research Grant, Investigation of Computer-Generated Photography, University of Alabama at Birmingham, 1990; Alabama State Council on the Arts, Media/Photography Grant, 1988; New Photographics/86, Purchase Award, Ellensburg, Washington, 1986; National Endowment for the Arts, Artists' Forums Grant, Washington, D.C., 1984.

The photographs in this series may appear to be the result of the use of filters, strobes, or other photographic manipulations, but they are not. The garish colors and bizarre landscapes are found in the environment. The bright orange-reds are created by neon signs casting light in isolated areas at dusk.

All cities are defined by their geography and by factors that have influenced their growth and development. The things that have affected the look of Birmingham are its lateral urban sprawl, lush vegetation, indigenous history, and resulting architecture. Commercial businesses with neon signs can often be found adjacent to shotgun houses or fields of kudzu where the piercing neon light reflects off remnants of an older world. The things that I have photographed—shotgun houses, kudzu, trees, and rain puddles—are semblances of the local culture.

In this series the images appear serene but are smoldering and portend a more sinister meaning about the identity of a city.

—*Sonja Rieger*

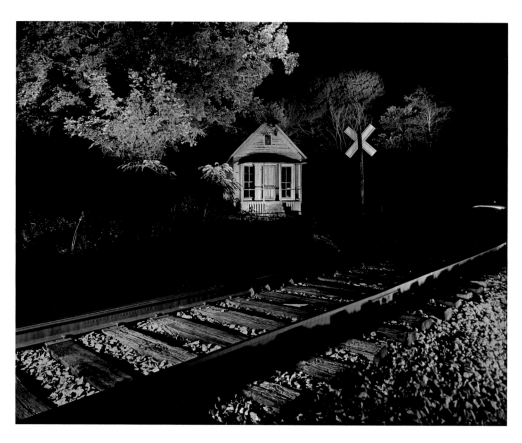

Thomas Tulis

Views from the Tracks: Store/Crossing

1991
Cibachrome print
20 x 24
Courtesy of Agnes Gallery, Birmingham

Foreign Policy by other means: Heavy Metal #91

1992
Cibachrome print
20 x 24
Courtesy of Agnes Gallery, Birmingham

Born in 1961 in Chattanooga, Tennessee.
Lives in Chattanooga, Tennessee.
Education: Studied drawing at Carnegie Mellon University.
Selected recent exhibitions: *Blacks and White*, one-man show, Dobbs Center, Emory University, 1996;
 PhotoWork '96, Barret House Gallery, Poughkeepsie, New York, curated by Miles Barth, 1996;
 Photo Biennial '96, Westport Art Center, Westport, Connecticut, 1996; *Tulis Art*, one-man show, Silent
 Pictures Gallery, Poughkeepsie, New York, 1995.

Toned Photographs

Richard C. Albertine

Mississippi Levee in Fog

1988
Toned and gilded gelatin silver print
11 x 14
Courtesy of Houk Friedman Gallery,
New York

Giant Cypress

1990
Toned and gilded gelatin silver print
11 x 14
Courtesy of Michael Shapiro Gallery,
San Francisco
Reproduced on page 16

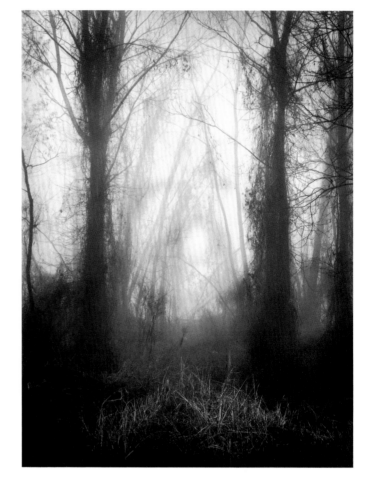

Born May 31, 1944, in Norwich, Connecticut.
Lives in Baton Rouge, Louisiana.
Education: AAS:BFA, fine arts–photography, Rochester Institute of Technology; graduate work,
 Massachusetts Institute of Technology; MFA, University of Delaware.
Selected recent exhibitions: *Flora in Photography*, Todd Kaplan Gallery, Santa Monica, 1996; *Richard Albertine*,
 Pheromone Gallery, West Hollywood, 1995; *Richard Albertine*, Michael Shapiro Gallery, San Francisco,
 1994.
Selected honors, awards, grants: Kodak Award of Excellence, Nexus Gallery, Atlanta, 1986.

The photograph *Mississippi Levee in Fog* was made in 1988 as part of an ongoing series of Louisiana landscapes. I was on the banks of the river early one morning in pea-soup fog so thick I could barely make out the outline of the vista through the lens of my trusty old view camera. Quite unexpectedly, the sun poked through just long enough for me to record the moment when the entire scene became visible. It was a beautifully ethereal but short-lived experience, for as quickly as it was revealed, the whole landscape dissolved into a fuzzy vision. Once again I was alone with only the sounds of distant fog horns and the eerie hissings and belchings of a nearby petrochemical plant. Fortunately the exposure was correct, and yet it remains the most difficult print I have ever undertaken in my thirty-plus years of camera work.

–Richard C. Albertine

Lynda Frese

Micaela's Room

1995
Digital image/Iris print
20 x 30

Born in 1956 in Jacksonville, Florida.
Lives in Breaux Bridge, Louisiana.
Education: BA, University of California, Davis, 1978; MFA, University of California, Davis, 1986.
Selected recent exhibitions: Mississippi Museum of Art, Jackson, 1995; Human Arts Gallery, Atlanta, 1995.
Selected honors, awards, grants: 1995 Regional Designation Award in the Arts from the Atlanta Committee
 for the Olympic Games Cultural Olympiad; Louisiana Division of the Arts grant for the second part of
 the collaboration *Reconstituting the Vanished,* titled *Baroness Pontalba and the Urban Shaping of New Orleans,*
 1995.

The subject of memory has for some time been an important theme of my art making. In its process, collage becomes a kind of remembering. It is a reinvention of a history or myth embedded in the photographs. I have an attraction for objects which evoke the past. I use symbols that move between and into realms that are personal, cultural, and universal. Most recently I have been delving into the signs and ethos of the Southern historical culture.

The photograph is located in a precise place and time in which it is first made. I have collected photographic images over the years that form a kind of visual library for my work. I use the combination of these images to alter and present another reality. It is a process of "peeling back" the past. In my artworks, time becomes fluid and cyclical rather than linear.

Just as postmodernism has challenged the truth status of history, digitization has challenged the truth status of photography. It is this parallel and philosophy that informs my work. Memory is not about static truth. By combining visual images and symbols, an involving narrative is created. Like the symbols employed, the story shifts between the personal and the archetypal. It is this "penumbra" of history which attracts me, the intuitive and subjective aspects of our memories.

–Lynda Frese

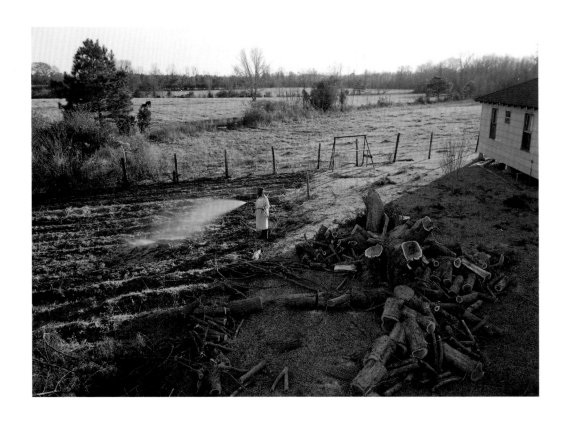

Thomas Neff

Mary George, Ethel, Louisiana

1986
Selenium toned gelatin silver print
20 x 24

Amy Deanna Gant, Old Mound House, Maringouin, Louisiana

1987
Selenium toned gelatin silver print
20 x 24
Reproduced on page 2

Gerald Jackson, St. Gabriel, Louisiana

1988
Selenium toned gelatin silver print
20 x 24

Born in 1948 in Los Angeles, California.
Lives in Baton Rouge, Louisiana.
Education: AA, Riverside City College, 1972; BA, studio art, University of California at Riverside, 1976; MFA, University of Colorado at Boulder, 1980.
Selected recent exhibitions and awards: *Louisiana Competition*, Louisiana Arts and Sciences Center, Baton Rouge, Purchase Award, 1993; Sixth Annual McNeese National Works on Paper Competition, Purchase Award, 1993; *Tri-State Plus '93*, Beaumont Art League, Beaumont, Texas, Purchase Award, 1993; *Magic Silver Show*, University of Northern Iowa, Cedar Falls, Purchase Award, 1993; *Southern Documents*, North Georgia College, Dahlonega, Georgia, 1991.

Not to be overlooked is the just plain horse of dubious pedigree and faulted conformation found on farms and in backyards. An experienced horse fancier would pass him by, but he can turn a child into a gallant knight, a Wild West marshal, or a reincarnation of Jeb Stuart or Nathan Bedford Forrest. Perhaps his real value exceeds that of the blooded horses of the race tracks and show rings.
　　　　　　—Frank Hampton McFadden, The Encyclopedia of Southern Culture

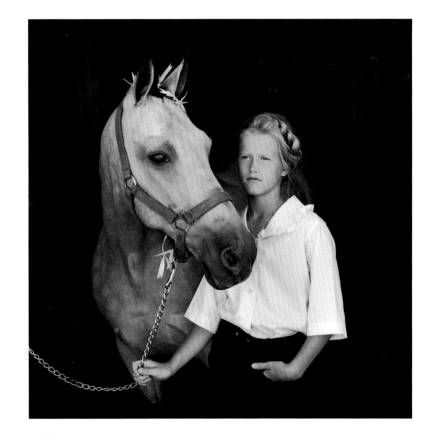

Mary Noble Ours

Jenelle with Bucky

1994
Toned gelatin silver print
16 x 20
Courtesy of Hemphill Fine Arts

B. J. with Horse

1994
Toned gelatin silver print
16 x 20
Courtesy of Hemphill Fine Arts
Reproduced on page 5

Born in 1955 in Fort Meade, Maryland.
Lives in Washington, D.C.
Education: BFA, photography, Ohio University, 1977.
Selected recent exhibitions: Hemphill Fine Arts, *Tri-County Fair, Petersburg, West Virginia,* Washington, D.C.,
　　1994; *Artists and Patrons*, Washington Project for the Arts, Washington, D.C., 1993.
Selected honors, awards, grants: Purchase Award, *Paris Courtyard*, Huntington Gallery, 1980; Purchase Award
　　and Award of Excellence, *Elmira's Room*, Huntington Gallery, 1980.

　　A country fair is a timeless marker of summer in rural areas. These images speak of ages of young people involved in the care and exhibition of animals they love.
　　　　　　　　　　　　　　　　　　　　　　　　　　　　　—Mary Noble Ours

Margaret Sartor

Katherine in Playhouse, Monroe, Louisiana
1989
Selenium toned gelatin silver print
16 x 20

Front Porch, Durham, North Carolina
1994
Selenium toned gelatin silver print
16 x 20

Deviled Eggs, Alto, Louisiana
1985
Selenium toned gelatin silver print
16 x 20

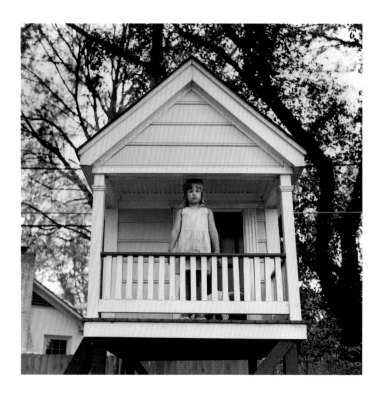

Born August 12, 1959, in Monroe, Louisiana.
Lives in Durham, North Carolina.
Education: BA, English, University of North Carolina at Chapel Hill, 1981.
Selected recent exhibitions: *Home: Photographs by Margaret Sartor*, Juanita Kreps Gallery, Center for
Documentary Studies at Duke University, Durham, North Carolina, 1995; *Photo Biennial 1994*, Westport
Arts Center, Westport, Connecticut, 1994; *Four Latent Image Photographers: John Moses, Elizabeth Matheson,
Margaret Sartor, Caroline Vaughan*, Bivins Gallery, Durham, North Carolina, 1994.
Selected honors, awards, grants: Second Prize, *Photo Review* Annual Competition, 1995; Third Award, *Photo
Biennial 1994*, Westport Arts Center, Westport, Connecticut, 1994; Third Prize, *Photo Review* Annual
Competition, 1994.

Born and raised in northern Louisiana, I made most of these photographs on the same streets and in the
same houses I knew as a child. Some I made in other locations around the South, particularly during my
family's annual summer retreat to the Gulf coast of Alabama. Because I live most of the time in North
Carolina, I photograph my family during holiday and vacation visits, usually a few weeks each year. This
series of pictures, begun almost a decade ago, has taken shape slowly, as the individuals and relationships
have naturally evolved and changed. Many of these faces I've known since I can remember. And though
events in my adult life clearly led to this project, I'm convinced the impulse goes back to my childhood
diaries, an early and powerful need to record the experiences to which I am drawn or connected. Later,
making elaborate scrapbooks, I would choose images and artifacts from my life to cut and paste and make a
story. Like those locked books and bulging albums, this series of photographs depicts an everyday world,
present and real, but also a world imagined, seen through the dark glass of memory and longing.

My family, like the life and landscape of the contemporary South, has its own peculiar sense of time
and history—a puzzle of faith and fear, reverence and humor, tradition and isolation, everyday banalities,
profound beauty, and ever underlying personal strength. It is with an unrelenting curiosity that I return and
record. For me, home has always been, and remains, something essentially sacred and often mysterious. I
believe the photographs present what comes down to a kind of recognition, emotion become visual fact,
lives watched, moments felt more than understood.

—Margaret Sartor

Luther Smith

North Carolina 1989

1989
Gelatin silver print
8 x 10

By the grace of God, my kinfolks and I are Carolinians. Our Grandmother Bowen always told us we had the honor to be born in Carolina. She said we and all of our kissing kin were Carolinians, and that after we were Carolinians we were Southerners, and after we were Southerners, we were citizens of the United States. . . . Speaking in a calm and confident tone, [she] said heaven would be like Carolina in the month of May in the early morning. The sun would never rise more than an hour high, and there would be peace and rest forever.

—Ben Robertson, Red Hills and Cotton

Born March 16, 1950, in Tishomingo, Mississippi.
Lives in Fort Worth, Texas.
Education: BA, photography, University of Illinois, Urbana; MFA, photography, Rhode Island School of
 Design.
Selected recent exhibitions: solo exhibition, Monmouth College, Monmouth, Illinois, 1995; North Texas
 Photography Invitational, Tarrant County Junior College NW, Texas, 1994.
Selected honors, awards, grants: National Endowment for the Arts Regional Photographers Fellowship, 1993.

As a man who spent his first ten years in Mississippi and the past thirteen years in Texas, I believe all my pictures are about me and my view of the world. Those first years growing up in the woods of northeast Mississippi have colored the rest of my life.

Since moving to Texas I have been photographing landscapes extensively. I recently completed a series of photographs of the Trinity River that flows through Dallas and Fort Worth and is the water source for over four million people.

I am currently working on a body of photographs of Southern landscapes. My mother moved back to the town in the area where I grew up, which gives me a home base from which to work.

—Luther Smith

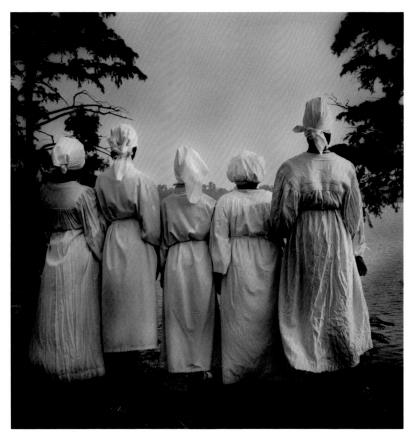

Jack Spencer
Baptismal Candidates

1995
Sepia toned gelatin silver print
14 1/4 x 14 1/4

Born in 1951 in Kosciusko, Mississippi.
Lives in Nashville, Tennessee.
Education: Self-taught, has been photographing for twenty years.

We were already in the middle of the bridge before we realized that there was a baptism in progress at the river's edge. Forty or fifty people stood in a semicircle in front of the cars and trucks, facing the river. Their attention was focused on the minister, who stood in shallow water, flanked by a young man and a young woman. These three, facing the congregation, had their backs to us, but we could see that the minister was reading from a big Bible that he held up in both hands, his head and shoulders tilted back to balance the weight of the book.

I slowed down and stopped, trying to take it in—the lowering skies, the skeins of Spanish moss moving softly in the wind, this solemn gathering by the river. Our normally acute sense of Sabbath-day propriety deserted us entirely, and I think we would have sat parked on the bridge, gawking as rudely as any tourists, had not several somber faces in the congregation lifted to look at us, and the minister, by a slight twisting of the neck, indicated that he was aware of our presence. It was enough to show me what we were—two men in a truck, with Yankee license plates and a canoe on top, stopping to stare. I put the truck into gear and slunk on across the bridge, still watching out of the corner of my eye.

—*Franklin Burroughs*, The River Home: A Return to the Carolina Low Country

Melissa Wilson
My Father's Parents

1993
Mixed media collages
12 ¼ x 12 ¼ each

Born January 27, 1957, in Norfolk, Virginia.
Lives in Louisville, Kentucky.
Education: BA, University of Louisville, 1981;
 MFA, University of Cincinnati, 1983.
Selected recent exhibitions: *A Woman's Work*, Huff Gallery,
 Spaulding University, Louisville, 1996; *Not So Still*, an
 invitational at the YWCA Gallery, Cincinnati, 1996.
Selected honors, awards, grants: First place, advanced
 division, Paducah Summer Festival Photo Competition,
 Paducah, Kentucky, 1995; Visual Arts Grant Recipient,
 Kentucky Foundation for Women, 1994; Artist
 Residency and Fellowship, Virginia Center for the
 Creative Arts, Sweetbriar, Virginia, 1994.

Like artists everywhere, I am asking basic questions
through my work: "Who am I? Where do I come from?
Where am I going? What do I believe?" But as an artist
born and raised in the South, the visual form these
questions take is one tempered by the Southern
experience.

I am only the third generation of my immediate family
to have more than a high school education. I am only the
second generation to have abandoned the Southern Baptist faith. Paradoxes abound. My parents marched for
civil rights; yet they employed a black woman to clean our house and to take care of
me. And although I come from a long line of strong, intelligent women, I am the only one of my generation
to embrace a feminist voice. My sisters and I grew up in the city, but many of my cousins, aunts and uncles,
and grandparents still live in the country. Having spent much time with them growing up, I find I have been
greatly influenced by "the look" of their lives.

Frequently, the things they take for granted are the things I love the most—the syrupy religious prints on
my aunt's kitchen wall, the curio box embedded with marbles and a "real glass eye," the toaster cover "doll"
that skirt-flips from a mammy to a Southern belle.

My relatives are often eager to be rid of these things, and are quick to embrace technology, particularly
in the form of "labor-saving devices." They think I am crazy for not having things like cable TV and a dish-
washer in my home "in the city." They are the living links to my past, and we do not cherish the same things.

This loss informs much of my work. In my longing for these things which cannot be retained, I am a
keeper of things—old photos, letters, scraps of paper, books, buttons, hats and gloves, whatever. These
things turn up in my work, sometimes literally, sometimes metaphorically.

I have inherited the remnants of three generations. What to keep? What to save? What to throw away?
What has value? What is worthless? Who decides?

—*Melissa Wilson*

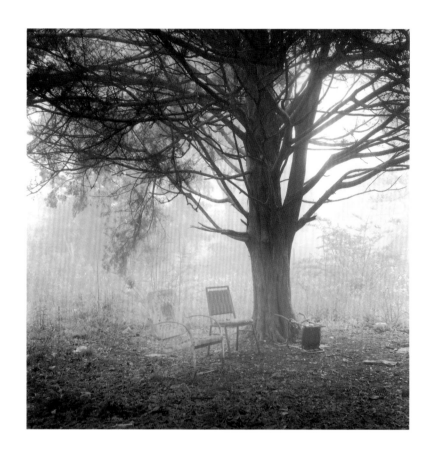

Diana C. Young
People's Park
1992
Duotoned gelatin silver print
16 x 20

Born in 1948 in western Kentucky.
Lives in Hattiesburg, Mississippi.
Education: BA, photography, University of Kentucky.
Selected recent exhibitions: *D. C. Young Photographs*, Main Street Gallery, Starkville, Mississippi, 1996; *D. C. Young: The Art of Documentary*, Photographic Gallery, Department of Photography, Middle Tennessee State University, Murfreesboro, 1996; *Looking for Mississippi*, Statewide Exhibition Program, Mississippi State Historical Museum, 1993–95.
Selected honors, awards, grants: Mississippi Humanities Council Grant for Ethnic Traditions in Mississippi Craftsmanship , 1996–97; Mississippi Urban Forestry Council Award, 1994; Regional Artists' Projects Grant (NEA/Rockefeller/Warhol) for Hub City Panorama, documentary project and exhibition, 1992–93.

People's Park is the vacant lot that exists in everyone's community. It once had a house, a family, and a history. Today it is the place for impromptu meetings and late-night gatherings. It belongs to the people of the surrounding neighborhood, and they adapt it to their needs. Each day it is different. A stool was overturned the day I took this image. Did this mean there was a late-night disagreement, or was it simply a matter of chance? It is a place of mystery, and I hope that every person who views this photograph will add their own reality and imagination to the meaning of *People's Park*.

–Diana C. Young

Black and White Photographs

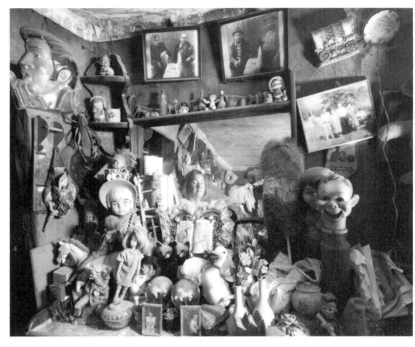

Shelby Lee Adams

Nora's Bedroom

1995
Gelatin silver print
16 x 20

Born October 24, 1950, Hazard, Kentucky.
Lives in Pittsfield, Massachusetts.
Education: MA, University of Iowa; MFA, Massachusetts College of Art.
Current project: Presently working in the Chattanooga public schools on a documentary book about
 schoolchildren and their families; continuing project of following a migrant farm family from their
 work in the fields of the southeastern United States back to their home in the Rio Grande Valley in
 Mexico.

*As a college art student, I discovered photography and became acquainted with the Farm Security
Administration and Depression-era photography done in the South. My professors always talked about
this work in the past tense, as if the problems examined in these photographs were solved long ago and
had little social or political importance during the Vietnam War period of my college days. The work of
Walker Evans, Marion Post Wolcott, Russell Lee, and others moved me in an intensely personal way and
jogged childhood memories. Those memories of Kentucky and the FSA photographs stirred me to begin
my own photographic search. I also studied the work of Diane Arbus, Ralph Eugene Meatyard, Duane
Michaels, and Clarence John Laughlin and later was inspired by the work of Mary Ellen Mark, Bruce
Davidson, Emmet Gowin, and Frederick Sommers.*

*During my summer vacations I took Depression-era photography books home with me and shared
them with my family in eastern Kentucky. My uncle, a country doctor, upon seeing the photographs,
said, "These people still live around here; they haven't changed in fifty years. You need to come with me
when I make house calls in the heads of these hollers." My uncle was and still is a kind of folk hero to
the mountain people of eastern Kentucky, and he made the perfect introduction to them for me in the early
1970s. On his calls, Doc Adams packed his doctor's bag with medical supplies and equipment and a
.38 caliber Smith & Wesson. When people couldn't afford to pay, my uncle would barter his services,
accepting a bag of potatoes, a mess of green beans, or a quart of moonshine as payment. I learned how to
trade and barter; to joke; to eat wild game such as raccoon, squirrel, possum, and rabbit; shoot guns; and
drink. Most importantly, I came to respect the mountain people and to enjoy their company.*

–Shelby Lee Adams, Appalachian Portraits

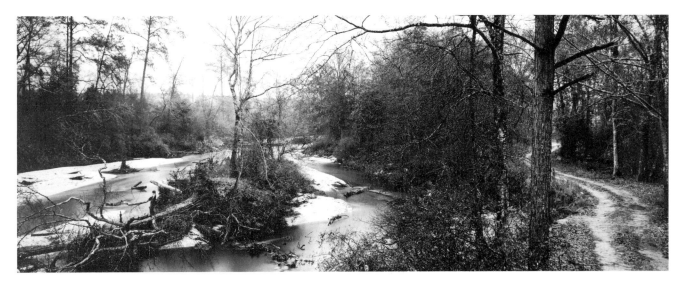

I remember lying on my back and gazing up at how the sunshine looked, like light through a stained-glass window, emerald green are iridescent in the leafy tops of the tallest trees. The river was as smooth and shiny as a mirror.

—*Lee Smith*, Tongues of Fire

Walter Beckham
Sizemore Creek, Escambia County, Alabama

1995
Chloride contact print
7 1/2 x 19 1/2

Born November 27, 1949, in Mobile, Alabama.

Lives in Mobile, Alabama.

Education: University of Montevallo; University of South Alabama; studied with Michael A. Smith in Ottsville, Pennsylvania, in 1986.

Selected recent exhibitions: *Encounters: Walter Beckham*, Huntsville Museum of Art, 1993; *Montgomery Biennial: Chiaroscuro: A Contemporary Study of Light and Dark*, Montgomery Museum of Fine Arts, 1994.

Selected honors, awards, grants: First prize, *Alabama Wetlands Photography*, Center for Cultural Arts, Gadsden, Alabama, 1993.

My photograph *Sizemore Creek, Escambia County, Alabama* is from a current project, *Photographs of Alabama*. I began this project in 1990, working on it on weekends and days off from work. It was only this year, six years into the project, that I realized I had found a life's work. This photograph was made while I was out in the field with a friend.

I had decided to weave portraits into the *Photographs of Alabama* series and was excited to be looking at the landscape again. My friend was taking me to see an abandoned factory of some kind, down a county highway, when we approached a hill of red clay blocking the bridge over Sizemore Creek. We walked out to the bridge, and I observed this view of the creek on a cloudy February day. After a few trips to the car, and fifteen minutes of setting up and composing, I was ready to make this picture. The rain came, and I huddled under the umbrella trying to keep the camera, the film holders, and myself dry. I got to live with my composition for longer than usual—it rained for twenty minutes or so. The situation was humorous; I was under the umbrella saving my equipment and my friend was in his car having lunch. The rain stopped, and I made my picture. I had a bonus from the rain—drops of water clinging to the leafless tree limbs.

The style of my work is not Southern, but the subject matter and the attention to detail are. The slowness and exactitude of working with large-view cameras has, to me, a correlation of working with the descriptiveness of Southern literature. Also, I prefer to photograph the familiar, and Alabama is my home. It is where I was born, grew up, and have lived my life.

—*Walter Beckham*

We understand it was the Civil War which made our country what our country is rather than the Revolution. The Revolution started us out, but the Civil War decided which way we were going.

 –Shelby Foote

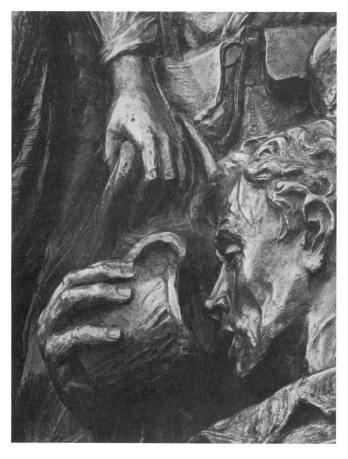

To understand it all, you must remember that the South was dominated, was possessed by an idea—the idea of the Confederacy. It was an exalted idea—supremely vivid, supremely romantic— but, after all, it was only an idea. It existed nowhere within the bounds of the actual unless the souls of its devoted people may be regarded as actual. But it is the dream, not the actuality, that commands the noblest devotion, the completest self-sacrifice. It is the dream, the ideal, that has ruled mankind from the beginning.

 –Ellen Glasgow, Dare's Gift

Marion L. Brown

Cup and Hand, Civil War Statue, Detail, Vicksburg, Mississippi, 1993

1993
Gelatin silver print
13 1/2 x 10 1/2

Born in 1925 in Greenwood, Mississippi.
Lives in Yazoo City, Mississippi.
Education: BS, Mississippi State University.
Selected recent exhibitions: *Marion Brown*, International Photography Hall of Fame and Museum, Oklahoma, 1996; *Marion Brown*, Main Street Gallery, Winfield, Kansas, 1995; *Contemporary Photography from the Helmut Gernsheim Collection*, Roemer Museum, Hildesheim, Germany, and Ikona Gallery, Venice, Italy, 1995.
Selected honors, awards, grants: Silver award, Mississippi Museum of Art, Competition for Mississippi Artists, 1991; nominated for Mississippi Institute of Arts and Letters Award Photographer of the Year, 1989 and 1992.

 By isolating a fragment from a very large Civil War statue, I feel that mystery is added to *Cup and Hand, Civil War Statue, Detail, Vicksburg, Mississippi*, but more importantly, for me the fragment focuses on the agony of war suffering.

 –Marion L. Brown

Tim L. Buchman

Bellamy Mansion, Wilmington, North Carolina
1989
Gelatin silver print
8 1/2 x 11

North Carolina State Capitol House of Commons
1989
Gelatin silver print
8 1/2 x 11

Born in 1950 in Columbus, Ohio.
Lives in Charlotte, North Carolina.
Education: BFA, Ohio University; Ohio Institute of Photography.
Selected recent exhibitions: *The Art of Building*, The National Building Museum, Washington, D.C., 1994;
 The Art of Building in North Carolina, traveling exhibition, 1992; York County Museum juried traveling
 exhibition, 1992–93.
Selected honors, awards, grants: AIA International Book Award, 1991; Ohio Instructional Grant, 1983.

I guess as an outsider, having been born and raised in the North, it's difficult to speak precisely as to what constitutes "Southerness" in these two places. It has occurred to me that probably the experience of traveling to these places has more than anything defined "Southern" for me—being immersed in the rhythm of a new geography and history and culture; driving through tobacco and cotton fields, down long stretches of straight, hot roads; passing through endless small towns; filling up on BBQ and iced tea. In a very real way I'm being primed for each destination. The images are created as aesthetic responses, but hidden in them are the history and the tales of the stuff that we refer to as "Southern."

–Tim L. Buchman

Debbie Fleming Caffery

Papa

1987
Photogravure
26½ x 24
Courtesy of Howard Greenberg
Gallery, New York

Enterprise Sugar Mill

1985
Photogravure
26½ x 24
Courtesy of Howard Greenberg
Gallery, New York

Polly

1986
Photogravure
26½ x 24
Courtesy of Howard Greenberg
Gallery, New York

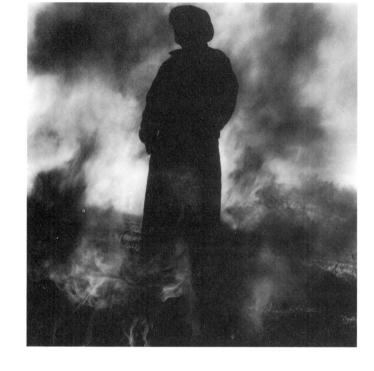

Born March 6, 1948, in New Iberia, Louisiana.
Lives in Franklin, Louisiana.
Education: BFA, San Francisco Art Institute.
Selected recent exhibitions: Catherine Edleman Gallery, Chicago, 1995; *The Personal Documentary*, Center for
 Creative Photography, Tucson, Arizona, 1994; *Devotion, Faith, and Fervor*, Howard Greenberg Gallery,
 New York, 1995; Aperture's *Fortieth Anniversary Exhibit*, New York, 1993.
Selected honors, awards, grants: Governor's Art Award, Professional Artist of the Year, 1989.

My search in photography has been a process of refining my response to the mysteries of life. My
images are of people and landscapes surrounded by an atmosphere of fog, smoke, and fire and are long
exposures with blurred or out-of-focus elements that help explain the unexplainable. My preference for black
and white allows me to work with darkness, light, and shadow to impact a mood in the work that reflects
my sense of mystery in what I see. Certain conditions of weather, and expressions or gestures of my subjects
arrest me, and the resonance begins. I try to distill into the photographs a visual sense of what is beautiful
and sometimes confusing, an emotional organization of feelings, textures, and light. I wish the steam could
float out of the prints and touch the viewer on the cheek, as I felt it while photographing.

—Debbie Fleming Caffery

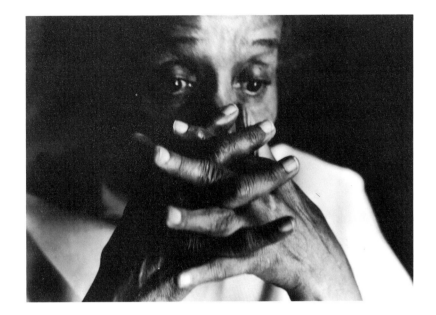

Francis Giles
My Mother Aging #2
1990
Gelatin silver print
16 x 20

Born July 9, 1946, in Chicago.
Lives in Fort Lauderdale, Florida.
Education: BA, educational psychology, Northwestern University, 1968–71; M.I.T. graduate fellowship
 with Minor White, 1972–73; Goddard College, graduate study in the history of twentieth-century
 photography, 1985–86.
Selected recent exhibitions: *Bound to the Land*, a documentary book, exhibition, and film about the Gullah
 people of the Sea Islands of South Carolina and Georgia.
Selected honors, awards, grants: Best New Photographer of 1987, Maine Photographic Workshop Annual
 Awards, New York, for *On Aging, My Mother.*

My mother had been beautiful, youthful, and alive and had been an innovative and dedicated kindergar-
ten teacher for thirty-seven years in Chicago. She had a master's degree. After retiring, she taught briefly
among the Indians in New Mexico. In 1976 she was selected Woman of the Year by a New Mexico group,
and now this. She did not look like this haggard crone before me. I had not seen my mother in three years,
but it was simply not possible for her to age thirty years and drop forty pounds all in the space of three short
years, was it?

First at the door and again inside the house, my mind raced through confusion, denial, and guilt, still
not letting on that there was anything wrong. Somehow I must have neglected my mother and this was the
result, was all I could think. Immediately my family flew Mom back home to Chicago for medical testing.

The diagnosis was Alzheimer's disease—no known cure. My mother had some latter-day plague and no
one knew anything definitive. I cannot recall the words she spoke; certainly they were trivial and they were
paranoid, for she was terrified of everything and she trusted no one. Alzheimer's disease is an organic brain
syndrome, a dementia. As functions are lost, they cannot be reclaimed.

As I was driving her to O'Hare Airport for her return to New Mexico, she said, "I cannot leave; take me
back this instant to the Millers'." When I said, "We will miss your flight," she asserted, "I am your mother, do
as I say." I was confused but I did exactly what she said. I brought her right back. All the while wondering,
"Am I crazy listening to her?" Then I would think, "But she is my mother," and on we drove.

As we parked, I began a litany. "Mom, we need to hurry to make your flight," was how it began. "Do
you think you might have left something inside?" I continued. After a quick check in the house, I said, "Let's
go to the airport together, Mom, and I will see you off." And off we were with no further hesitation.

At the airport, the attendants were more assured than I. They were perfectly calm and allowed me to
walk her on board and strap her into her seat. Then I kissed her good-bye. Later that evening I spoke with
Victor. "I had a hell of a time getting Ruby to leave the airport," he said. "She kept saying she could not find
her little boy, Frank, and she was not going to leave there without you."

–Francis Giles

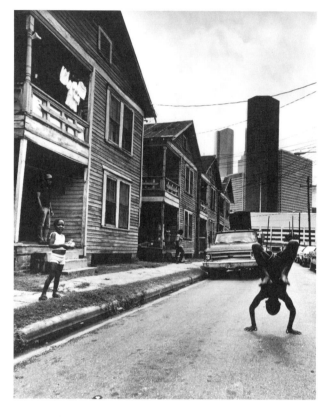

Earlie Hudnall, Jr.

Flipping Boy

1986
Gelatin silver print
16 x 20

Born on November 8, 1946, in Hattiesburg, Mississippi.
Lives in Houston, Texas.
Education: BA, art education, Texas Southern University, 1976.
Selected recent exhibitions: *Project Row Houses*, Houston, 1995; Project Galveston: *Earlie Hudnall, Jr., and the Children of the Galveston Housing Authority*, Galveston Art Center, Galveston, Texas, 1994.
Selected honors, awards, grants: *Texas Art Celebration '92*, Second Prize, Assistance League of Houston, 1992; ADA Photographic First Annual Competition, First Place in Black and White, 1987; Art in Community Places, Cultural Arts Council of Houston Visual Artist's Grant, 1981.

My interest in photography was inspired by my father, who was an amateur photographer. He would always take pictures of us on the fourth Sunday after church. Then there was my grandmother, who was to us the community historian, for she kept a photo album that contained pictures and news clippings of events and obituaries of family and community persons. This album was used to provide a visual and detailed interpretation of her stories of how life used to be, or where and how people lived, or how country dwellers communicating while sitting on the porch at night would keep a smoke bucket close by to ward off the mosquitoes.

Often in the middle of her stories, she would laugh and reach to get her Garrott Snuff, which she kept near her chair. When telling us long stories my grandmother often referred to important dates she kept in the family Bible.

At that time, I began to understand the importance of keeping a visual record of the family, of the community, and of our surroundings. The love for this common way of life and the memories of those times provided me with the inspiration to become a photographer, just as Grandmother used the photo album and the family Bible.

–Earlie Hudnall, Jr.

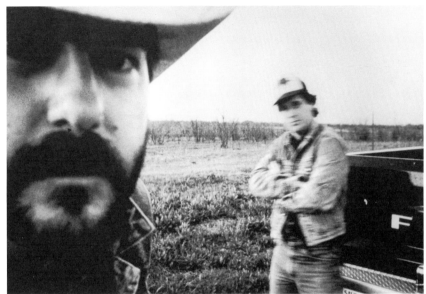

Tom Jenkins

Outskirts of Los Colinas

1990
Gelatin silver print
16 x 20

Señoritas

1991
Gelatin silver print
16 x 20

Born November 24, 1953, in Landstuhl, Germany.
Lives in Dallas, Texas.
Education: BFA, Kansas City Art Institute, 1974.
Selected recent exhibitions: *Tradition and the Unpredictable*, group exhibition, Houston Museum of Fine Arts,
1994; *Gesture and Pose*, group show, Museum of Modern Art, New York, 1994.
Selected honors, awards, grants: Two Montgomery Awards for photography for the Dallas Museum of Art's
catalogue *American Silver from 1840 to 1940*; second place, McIlheney Company Award for Regional
American Cookbooks for *Artful Table*.

I rarely like or get anything from artists' statements. They are often so pretentious, have little to do with
the work, and ultimately steer me away from the work. I suppose I have no statement per se . . . maybe
some suggestions concerning work ethic or attitude or perhaps a few quotes would be a more accurate
representation of my thoughts . . . (pardon my paraphrasing):

There is nothing more mysterious than a fact clearly stated.
—Lee Friedlander
There are more photographs than bricks in the world.
—John Szarkowski
Senseless activity gives meaning to our lives.
—Mike Kennedy
I'd rather be taking pictures.
—Alfred Stieglitz
There's a picture here somewhere, all I gotta do is figure out where to take it.
—Sid Kaplan
This work, I hope, stands on its own.
—Tom Jenkins

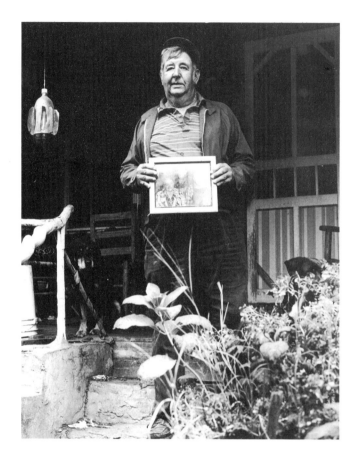

Jack L. Lawing
From Whence He Came
1993
Gelatin silver print
20 x 16

Born in 1938 in Marion, North Carolina.

Lives in Atlanta, Georgia.

Education: BA, history, University of North Carolina, 1960; graduate work, German history, University of Munich, 1960–61; J.D., Harvard Law School, 1964.

Selected recent exhibitions: *Arts in the Heart of Augusta*, Gertrude Herbert Institute of Art, Augusta, Georgia, 1995; All-Media Summer Exhibition, Contemporary Artists Center, North Adams, Massachusetts, 1995; Members' Show, Atlanta Photography Gallery, 1994.

Selected honors, awards, grants: *National Exposures*, Eastman Kodak Company Professional Imaging Division Award, Associated Artists of Winston-Salem, Winston-Salem, North Carolina, 1994.

I was born and raised in the mountains of North Carolina. It was not until I returned after spending several years in New England that I realized the uniqueness of the language, idioms, and customs of what I had always regarded as the norm.

Much of my early work had been either nature or travel photography. Almost by accident I discovered that all around me was a singular eccentricity that should be recorded. The more I looked, the more I saw— and the more I photographed. It seemed to me that the mountain people, above all, exhibited the wacky side of individuality and creativity, and they were not bashful in showing it.

Most of my photographs are from the Georgia mountains, which are the most accessible from my home in Atlanta. Coleman Stanley lives alone in Cherry Log, Georgia. He misses his parents, whose photograph he proudly displays. He is a Southern mountain man, dressed in typical bib overalls, who extended his hospitality to me and his menagerie of yard animals on the front porch of his neglected home.

—Jack L. Lawing

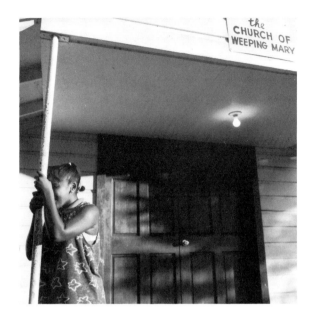 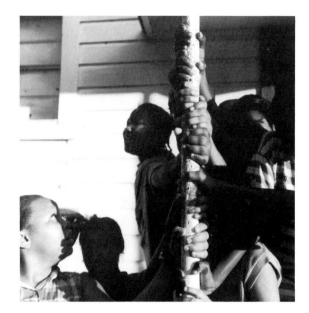

O. Rufus Lovett
Hide and Seek, Weeping Mary, Texas

1995
Gelatin silver print
15 x 15

Born in 1952 in Jacksonville, Alabama.
Lives in Longview, Texas.
Education: BA, photography and journalism, Sam Houston State University, 1973; MA, photography, East
Texas State University, 1977; Ansel Adams Workshop, Yosemite, California, 1980; Mary Ellen Mark
Workshop, Dallas, 1994.
Selected recent exhibitions: Galveston Arts Center, Galveston, Texas, 1996; *Engaged Portraiture*, Art Museum
of Southeast Texas, Beaumont, 1996.
Selected honors, awards, grants: Award Recipient, Illuminance, Lubbock Fine Arts Center, Lubbock, Texas,
1995.

The diptych *Hide and Seek, Weeping Mary, Texas*, is a piece from a body of ongoing work that includes
images of interpretive observations from the daily lives of the children who live in Weeping Mary, Texas, a
small rural community that has existed since the Civil War. The children here grow to graduate from schools,
work for the highway department, work for the local forestry service or sawmills, and stay in Weeping Mary
rearing children of their own. Their lives are intertwined with those of parents, grandparents, cousins, uncles,
and neighbors, reflecting near poverty, enlightened by play and laughter and hope. At least for now the
future is theirs to dream about and, perhaps, to fulfill.

It is through visualization of the community that I wish to recognize the importance of the lives of these
children and their influences, almost hidden in this river-bottom flat among the East Texas piney woods. In
photographing Weeping Mary, it is my goal to create commentaries not only about the people but also about
their environment in terms of their relationship to it—how they are married to their place.

–O. Rufus Lovett

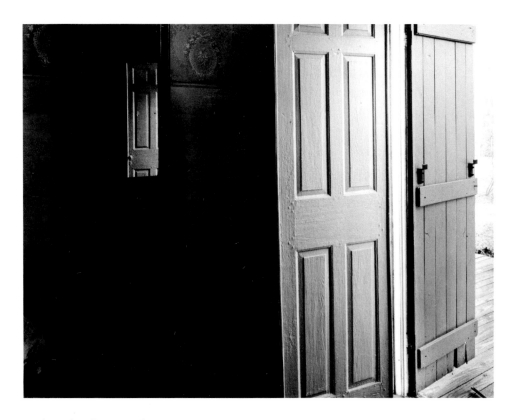

Elizabeth Matheson
Halifax County, North Carolina, 1995

1995
Gelatin silver print
11 x 14

Born in 1942 in Durham, North Carolina.
Lives in Hillsborough, North Carolina.
Education: BA, English history, Sweetbriar College, 1964; studied photography at the Penland School, Penland, North Carolina.
Selected recent exhibitions: *Four Latent Image Photographers: John Moses, Elizabeth Matheson, Margaret Sartor, Caroline Vaughan*, Bivins Gallery, Durham, North Carolina, 1994.

I can't imagine these photographs being made anywhere but in the South. This is an eighteenth-century house in the deep country of Halifax County, North Carolina, now inhabited by the last of the family that built it. I walked into the house, and it was as if I were put on earth to photograph it. This is the first photo I ever made there. The house is both ghost-filled and ravishing.

−Elizabeth Matheson

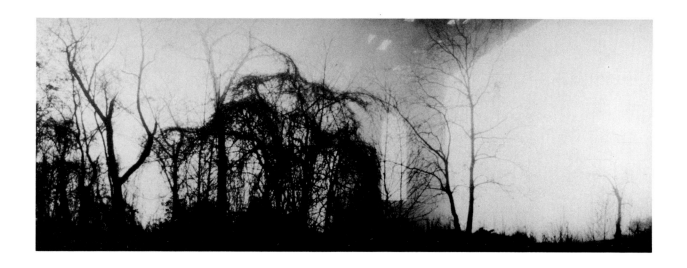

A. J. Meek

Trees, Fog, Bridge, and Plastic Bag

1989
Gelatin silver print
8 x 20

Mississippi River Flood, Baton Rouge

1990
Gelatin silver print
8 x 20
Reproduced on page 18

Exxon Fire and Explosion

1989
Gelatin silver print
8 x 20
Reproduced on page 18

Born August 29, 1941, in Beatrice, Nebraska.
Lives in Baton Rouge, Louisiana.
Education: BFA with honors, Art Center College of Design, 1970; MFA, Ohio University, 1972.
Selected recent exhibitions: New Orleans Historical Collection, a group show dealing with the sugarcane
industry, New Orleans, 1995–96; *Battlefield*, Hill Memorial Library, Louisiana State University, Baton
Rouge, 1995; *A Sense of Place, a Sense of Presence, and the Sacred Mesa*, AfterImage Gallery, Dallas, 1994.
Selected honors, awards, grants: Southern Arts Federation and the National Endowment for the Arts
Fellowship, 1993.

The Mississippi River is of an awesome power and spectacle. The Indians called it the Father of Waters.
I have seen huge trees the size of telephone poles disappear in its undertow currents only to suddenly
reappear again miles downriver. Unless one is actually on the levee, the river is obscured from view. From the
vantage point of the levee, one may observe sea-voyaging ships and barges navigating the twists and bends
of the river. Petrochemical plants sit along the banks, replacing the nineteenth-century plantations
that were the source of power and commerce for their time. Antebellum homes take their place along the
river and are ghostly reminders of all that remains symbolic of the Old South.

—A. J. Meek

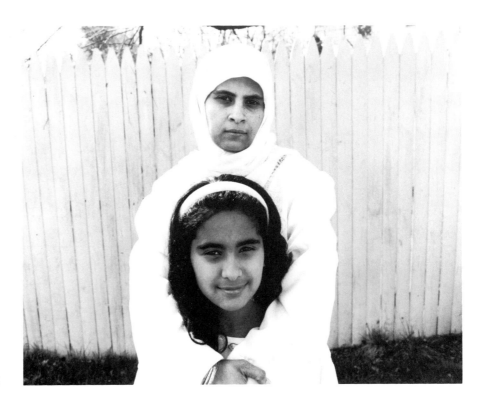

David Najjab
Hanan and Nora, Lexington, Kentucky

1995
Gelatin silver print
16 x 20
Courtesy of Photographic Archives Gallery, Dallas

Born July 12, 1961, in Dallas, Texas.
Lives in Garland, Texas.
Education: BA, University of Texas at Dallas; MFA, photography, Bard College, New York.
Selected recent exhibitions: *David Najjab Photographing Arab-America*, Center for Middle Eastern Studies,
 Cambridge, 1996; Tisch School of Art, 1996; University of California, Berkeley, 1995.
Selected honors, awards, grants: New York University American Photography Institute Fellowship, 1996;
 Milton Avery Fellowship, National Endowment for the Arts/Mid-America Arts Alliance Photography
 Fellowship; Departamento Exteriores de Mexico Award, Los Barrios en Texas Grant, 1996.

At the close of the twentieth century the South is a much more diverse place than its clichéd portrayal
in popular culture indicates. Many religious, ethnic, and racial groups make up the South of today. I am
an Arab Muslim living in the South. Like other members of my community I deal with complex political,
religious, and social issues that are poorly represented in today's media. My community is an integral part of
the new South. My photographs are a view of who and what we are from our perspective.

 –David Najjab

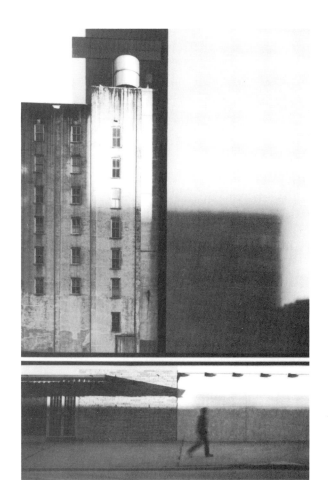

Michael Nye
City #4
1988–94
Gelatin silver print
22 x 28

Born in 1948 in Newton, Kansas.
Lives in San Antonio, Texas.
Education: BA, Texas Tech University; J.D., South Texas College of Law.
Selected recent exhibitions: Solo exhibition, Abilene Contemporary Gallery, Abilene, Texas, 1994; solo
 exhibition, Milagros Gallery, Blue Star, San Antonio, Texas, 1995.
Selected honors, awards, grants: National Endowment for the Arts/Mid-America Arts Alliance Photography
 Fellowship, 1991–92.

When I first began to wonder about images, I remember noticing the differences between what the
photographer saw and what the camera saw. I was attracted to these distinctions and the balance and weave
between the two worlds. Photography has many voices, but inherent in each image is the reminder that we
live in a rapidly changing world.

What is forgotten is lost. I have often thought of that sentence with regard to photography. Photographic
images are tied to remembrance, and although they are a shadow of what was seen, they still allow the past
to have a presence.

My interest in photography has continued to be centered around inquiry and the ways empathy and
understanding affect our visions and lives. In many ways I find a relationship between philosophy and
photography. How can I know more? What choices do I make? What is the meaning of what I see?
—Michael Nye

Susan H. Page

Beatrice with Hoe Out Back
Charlotte, North Carolina
1994
Gelatin silver print
16 x 20

Beatrice Fleming,
Charlotte, North Carolina
1992
Gelatin silver print
16 x 20

Beatrice after Washing Walls,
Charlotte, North Carolina
1995
Gelatin silver print
16 x 20
Reproduced on page 12

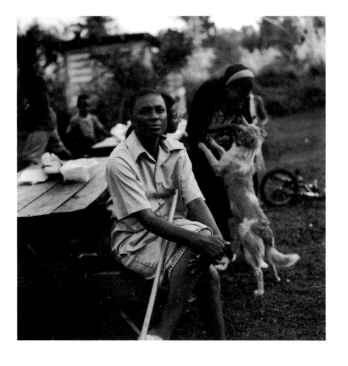

Born in 1959 in Greenville, Ohio.
Lives in Charlotte, North Carolina.
Education: Bachelor of Music, Michigan State University, 1981; Masters of Music, Michigan State
 University, 1983.
Selected recent exhibitions: Beatrice, solo exhibition, Afro-American Cultural Center, Charlotte, North
 Carolina, 1996; Israel Exhibition, group exhibition, Light Factory Photographic Arts Center, Charlotte,
 North Carolina, 1997; Close at Heart, group exhibition, Light Factory Photographic Arts Center,
 Charlotte, North Carolina, 1996.
Selected honors, awards, grants: Artist residency in Israel, awarded by the North Carolina Arts Council,
 Raleigh, 1995; project grant to continue *Working Women*, awarded by the North Carolina Arts Council,
 Raleigh, 1993; Fulbright travel grant to Italy, awarded by the Council for the International Exchange of
 Scholars, Washington, D.C., 1991.

I am continuing to develop a series of portraits and interviews about the life of an extraordinary woman,
Beatrice Fleming. I met Beatrice while I was working in a textile mill in Charlotte, North Carolina. She was
one of a group of women who worked at the mill and participated in a project with me called *Working
Women*. For this project I interviewed and photographed my co-workers, a group of African-American women
who spent long days doing very strenuous work under very uncomfortable conditions (cold in the winter,
hot in the summer). Even under these conditions they maintained a sense of dignity, pride, and sisterhood.
They sorted scraps of textile cuttings and clippings by content and color from the hundreds of mills that dot
the towns and villages of North Carolina.

I began to photograph and interview them. They told me stories about their lives which explored issues
of women in the workplace, single-parent families, child care, pregnancy, male-female relationships, the
textile community, civil liberties, and African-American folklore.

The current photographs I am working on with Beatrice grew out of a desire to extend the boundaries
of the photographs beyond the workplace. Beatrice and I developed a special relationship. She told me about
her first pregnancy at age thirteen, her sixth child by the age of twenty, and what it was like to grow up with
seventeen brothers and sisters. We talked about what it felt like to have members of your family beat up by
the KKK, and why it stopped raining when you threw a dead snake up in a tree.

—Susan H. Page

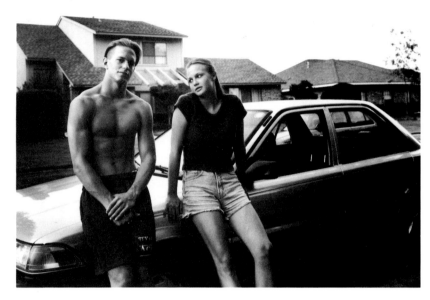

Patricia D. Richards

Caught Looking

1995
Gelatin silver print
16 x 20

Amy's New Boyfriend

1994
Gelatin silver print
16 x 20

Born May 13, 1947, in Oakland, California.
Lives in Plano, Texas.
Education: BA, University of Washington, Seattle, 1969; MS, University of Southern California, 1973; MFA, Southern Methodist University, 1993.
Selected recent exhibitions: *Documenting the Community*, Houston Museum of Fine Arts, Houston, Texas, 1994; *Familiar Strangers*, Print Club, Sixty-eighth Annual Competition curated by Charles Hagen, Philadelphia, 1994; *Neighborhood Snapshots*, E. J. Bellocq Gallery; *Family Pictures*, solo exhibition, Louisiana Tech University, Ruston, Louisiana, 1994.
Selected honors, awards, grants: National Endowment for the Arts/Mid-America Arts Alliance Photography Fellowship.

My pictures are about what I know: my home, family, friends, and neighbors in the spaces we occupy as we approach the year 2000. This work documents events of the suburban family. The often mundane occurrences, rendered as neighborhood snapshots, family pictures, remind me of photographs I viewed as a child while listening to stories well told by my grandmothers. The pictures they saved fueled my photographic cravings. Through the use of an 8 x 10 camera, I am continuing the legacy of familial imagery. From my seeing "snaps"—the girls in the doorway, the discovery of a dead bird in our yard, teenage traumas, and the boys at fifteen—life in all of its manifestations has presented itself to my lens and granted me access to daily wonders. I hope to produce a body of work that will serve for those yet unborn as a record of what life was like in a Southern American suburb at the turn of the twenty-first century.

—Patricia D. Richards

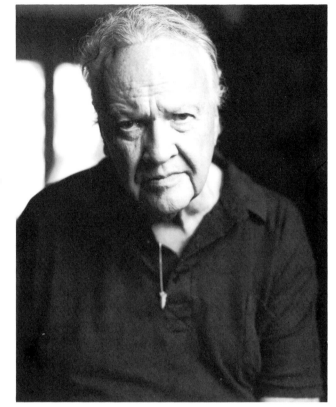

Anyone who wants to learn about the South should get to know her women. They are tough, loving, frail, and powerful. They hold so many of our best secrets.
—James Dickey

Curt Richter

James Dickey
> 1994
> Platinum/palladium print
> 8 x 10

Eudora Welty
> 1989
> Platinum/palladium print
> 8 x 10
> Reproduced on page 6

Born August 24, 1956, in New York City.
Lives in New York City.
Education: BFA, photography, State University of New York at Purchase, 1981.
Selected recent exhibitions: *Portraits*, Zelda Cheatle Gallery, London, 1993; solo exhibition, John Froats Gallery, New York, 1992; Fellowship of Southern Writers, permanent exhibition at the University of Tennessee, 1991.
Selected honors, awards, grants: John Simon Guggenheim Foundation Fellowship in Photography, 1992.

When a writer describes a character, he does not didactically recount every moment in that character's existence. A writer selects the events and emotions which define their essence. It was with this in mind that I began taking portraits.

Ironically, two years later, Louis Rubin commissioned me to photograph the founding members of the Fellowship of Southern Writers. *A Portrait of Southern Writers* is my epic and very likely the most challenging project I will ever undertake.

The book required many months of driving. Mile after mile of time to think. Any medium has its virtues and limitations. The difference between a writer's palette and a photographer's was something that took me across many state lines. Even if we tried to make similar images, we would have to find separate solutions to create them. That distinction was made beautifully clear by Mary Hood. At the end of a delightful afternoon, she showed me her grandmother's rocking chair. As Mary stared at it, she told me that her grandmother would never take a seat without moving it, even if just a little.
—Curt Richter

Carolyn L. Sherer

Katie
1995
Gelatin silver print
11 x 14

Ana
1995
Gelatin silver print
11 x 14

Tabitha Rena
1995
Gelatin silver print
11 x 14

All from *Junior Matriarchs of the South* series

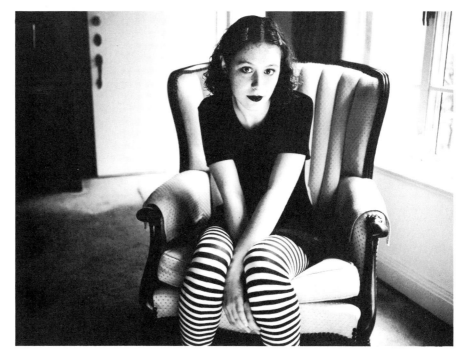

Who has ever heard of "The Midwestern Lady" or "The Northern Belle?"

—Gail Godwin

Born in 1957 in Jasper, Alabama.
Lives in Birmingham, Alabama.
Education: BS, University of South Alabama, 1980; MS, University of Alabama at Birmingham, 1984.
Selected recent exhibitions: *Uncommon Valor: Portraits of Alabamians with (Dis)Abilities*, Birmingham Civil Rights
 Institute, Birmingham, Alabama, 1995.

Full of contradictions like any adolescent, these Southern girls possess a quiet strength learned from matrons who taught them to revel in their femininity yet be ever ready to manage the family affairs. The South is legendary for its beauties, and its daughters are groomed from birth to look their best and value their womanhood. Contrary to myth, however, Southern women are not helpless. Due to grinding poverty and a history of losing their men, either temporarily or permanently to war, our women inherit a legacy of strength and an ability to provide for their families—with or without the use of feminine wiles.

—Carolyn L. Sherer

"Why!" she cried, "good country people are the salt of the earth! Besides, we all have different ways of doing, it takes all kinds to make the world go 'round. That's life!"
"You said a mouthful," he said.
"Why, I think there aren't enough good country people in the world!" she said, stirred. "I think that's what's wrong with it!"
His face had brightened. "I didn't inraduce myself," he said. "I'm Manley Pointer from out in the country around Willohobie, not even from a place, just from near a place."
"You wait a minute," she said. "I have to see about my dinner." She went out to the kitchen and found Joy standing near the door where she had been listening.
"Get rid of the salt of the earth," she said, "and let's eat."
—*Flannery O'Connor,* Good Country People

David M. Spear

Lee Neugent and Cat

1989
Gelatin silver print
16 x 20

Mamie Neugent Drying Hair

1989
Gelatin silver print
16 x 20

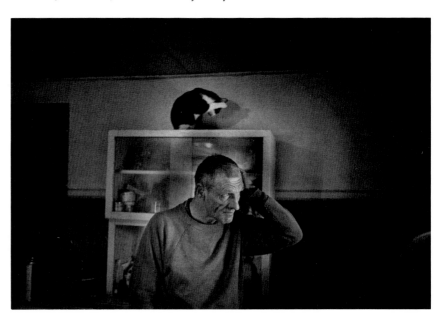

Born in 1937 in Madison, North Carolina.
Lives in Madison, North Carolina.
Education: BA, English literature, Guilford College, 1960.
Selected recent exhibitions: Solo exhibition, Hollins College, February 1996; *The Neugents*, Guilford College Art Museum, 1995; solo exhibition at the Media Center, Rice University, Houston, 1993.
Selected honors, awards, grants: Fellow, Headlands Center for the Arts, Sausalito, California, 1995; Guggenheim Fellow, 1993; North Carolina Artists Project Grant, 1991.

Eighty five year old Mamie Neugent's father farmed tobacco, like his father before him, and even became a landowner. But Mamie's late husband, Tracy Neugent, was not a landowner, and consequently most of his working life was given to farming tobacco on shares or in public work. Not until he had reached old age did the family buy land.

While some of Mamie and Tracy Neugent's children chose to leave tobacco, a core group remained on the land. Like those before them, they are the labor force. Bill Neugent and his wife Wanda (Nubby), along with his brothers Troy and Lee Neugent have comprised the primary work force in recent years. . . . Of all the children Lee is treated with the most concern.

I took Lee to Greensboro for the first time in his life when he was 50 years old. We went to the Friendly Shopping Center for lunch, but Lee wouldn't go into Jay's Delicatessen. He ate lunch in the truck. I took him to the airport to watch a plane leave. He froze in disbelief as a 737 broke ground, and allowed that, "the son-of-a-bitch could fly." When we got to Stokesdale, on our return home, I asked him if he knew where he was. He told me, "Hell yeah, I know. I am right here," and he looked at me and said, "Do you?"

—*David M. Spear,* The Neugents

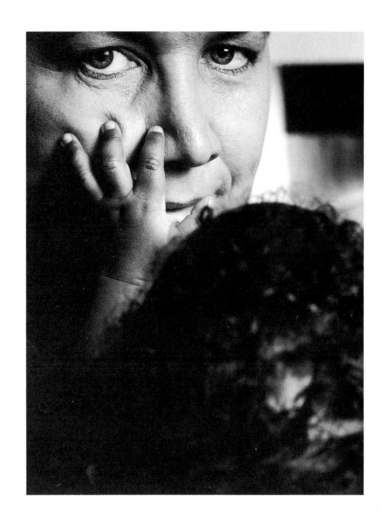

Melissa Springer

Glenda Hollis

1993
Gelatin silver print
20 x 24

Francine Drake

1993
Gelatin silver print
20 x 24

Vicki Covington

1993
Gelatin silver print
20 x 24

Born in 1956 in Winston-Salem, North Carolina.
Lives in Birmingham, Alabama.
Education: University of South Alabama, 1974–76.
Selected recent exhibitions: *Salvation on Sand Mountain*, Alexandria Museum of Art and Huntsville Museum of Art, 1996; *Melissa Springer*, Nancy Solomon Gallery, Atlanta, Georgia, 1995; *Alabama Impact: Contemporary Artists with Alabama Ties*, Mobile Museum of Art and Huntsville Museum of Art, Alabama, 1995; *Michael Tipton, World AIDS Day*, High Museum of Art, Atlanta, 1994; *Medical Revisions*, P.S. 122 Gallery, New York, 1994.
Selected honors, awards, grants: Grant Recipient, Alabama State Council on the Arts, 1994.

Glenda is the mother to children who cannot grow up. She is the foster parent of abandoned HIV-positive babies in Alabama. She teaches them that they belong on the earth and when it is time she turns their faces to the bright light and says, "It is good."

—Melissa Springer

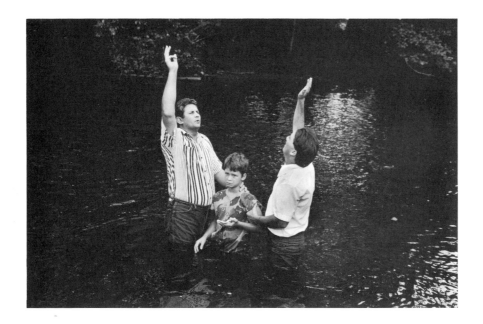

Mark Steinmetz
Baptism, Cocke County, Tennessee
1991
Gelatin silver print
16 x 20

Outside Rockwood, Tennessee
1991
Gelatin silver print
16 x 20

Knoxville
1991
Gelatin silver print
16 x 20

Born in 1961 in New York.
Lives in Athens, Georgia.
Education: BS, Wesleyan University; MFA, Yale University.
Selected recent exhibitions: *Delirium*, Ricco/Maresca Gallery, New York, 1996; *The Magic of Play*, Directors'
 Guild, Los Angeles.
Selected honors, awards, grants: Georgia Council for the Arts Individual Artist's Grant, 1995; John Simon
 Guggenheim Memorial Foundation Fellowship.

I moved from Chicago to Knoxville, Tennessee, in the fall of 1991 to accept a one-year teaching position
at the University of Tennessee. Before then I had never even been to the South and had known about it
mainly through its great writers. These photographs are among the very first I made in the South, and the
photo of the baptism in the creek was made in my first week there. I easily found what I hoped I might find.
I fell in love with the South right away—its chaos and happy overgrowth. I am still in love with the South
(now I live in Athens, Georgia), though the way I choose to describe it has changed a great deal.

—Mark Steinmetz

Fannie Capper
Woman with Lipstick

1990
Gelatin silver print
12 x 17³/₄
Courtesy of the artist and
 Lynne Goode Gallery, Houston

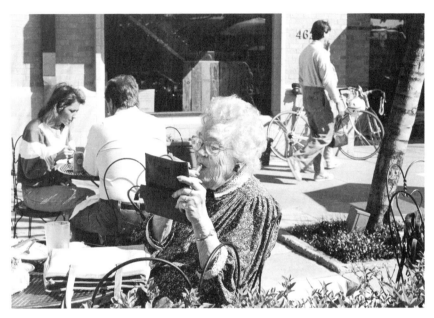

Born September 6, 1926, in Temple, Texas.

Lives in Houston, Texas.

Education: BA, Baylor University; Ph.D., Rice University.

Selected recent exhibitions: *Women and Their Secrets*, Women and Their Work Gallery, Austin, Texas, 1995; *A Grave Disease*, Council for the Visual and Performing Arts, University of Texas-Houston Health Science Center, 1995.

The subjects here are Southern women; moreover, they are close friends, and one is a member of my family. Like me, they are "Southern" and embody those Southern traits which to a Southerner are at the same time easily discernible and difficult to describe.

Although I have lived in Texas all my life, my roots are in the "deep" South. My paternal grandparents came out to Texas from the Piedmont area of Virginia after "the War" in 1887, at about the same time that my maternal grandparents came to Texas from Arkansas. Although the two families had been Americans since the 1700s, their earlier roots had been in England and Scotland and northern Germany. The cultures of our western European ancestors intermingling with the early pioneer culture of this part of the United States make up what we call Southern life.

In my frequent contacts with the international groups in Houston, I have observed that the last member of a family to assimilate into our culture is the mother. It is she who preserves the language, the family traditions, the social behavior of the homeland, while the children and the father more readily adopt the different customs of the new land. For this reason, from among my photographs I have chosen as best representative of the South these images not merely of women but of older women, the family matriarchs.

These are strong women who have seen much of life, and yet they maintain the courage, dignity, humor, vanity, and love of family that typify Southern women. Where else but in the South is your neighbor named Boo Boo? Where but in the South do family members and close friends kiss each other on the lips in greeting and farewell? Where else would a garrulous eighty-eight-year-old have had carved on her tombstone the epitaph, "She finally quit talking?" Nowhere but in the South have I seen women apply lipstick "in front of God and everybody" in a restaurant. And who more than a Southern woman loves her garden?

–Fannie Capper

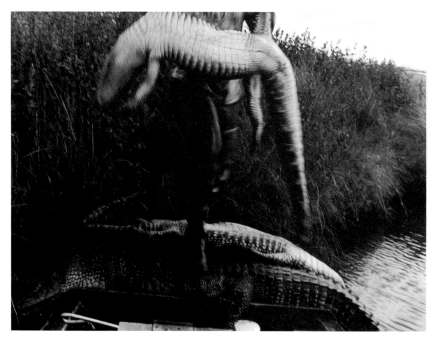

Constance J. Thalken

Mixture of Frailties

1993
Gelatin silver print
17 x 22

Below Zero

1991
Gelatin silver print
17 x 22

Born September 5, 1952, in Columbus, Nebraska.
Lives in Decatur, Georgia.
Education: BA, psychology, Barat College; MFA, photography, Yale School of Art.
Selected recent exhibitions: *Ancient Pieties: Maps of Mexico*, solo exhibition, DeKalb College, Clarkston,
 Georgia, 1996; Contemporary Southeastern Photography Exhibition, Alice and William Jenkins Gallery,
 Winter Park, Florida, 1995; *Photropolis*, San Diego Art Institute, San Diego, California, 1995.
Selected honors, awards, grants: Individual Artist Grant, DeKalb Council for the Arts, Decatur, Georgia,
 1996; purchase award for the Contemporary Southeastern Photography Exhibition, 1995; Faculty
 Research Award, Georgia State University, Atlanta, 1995.

This selection of photographs is drawn from work that I have done over the past seven years in the
South. This has involved placing myself in environments where the human presence plays a significantly
subordinate role to that of nature. It is in this context that issues of death, spirituality, the common nature of
human life and animal life are explored. I have been particularly interested in examining the border between
human and animal and the idea of common drives and emotions such as fear, a need for companionship, the
instinctual fight for survival, and the shared destiny of death. A recurring theme seems to be the notion of the
immense power of the life force and the paradoxical fragility of its physical embodiment.

What strikes me as "Southern" about this work is visceral in nature—the density of weight in the air
of the hot, humid South and the dark, brooding quality that is reflective of the region's proclivity for self-
examination and self-absorption.

–Constance J. Thalken

Frederick Baldwin
and Wendy Watriss

Saturday Night Country Wedding 1
1986
Gelatin silver print
11 x 14

Saturday Night Country Wedding 2
1986
Gelatin silver print
11 x 14

Frederick Baldwin
Born February 25, 1929, in Lausanne, Switzerland.
Lives in Houston, Texas.
Education: Attended Ecole Julian; BA, Columbia University, New York.
Selected recent exhibitions: *Texas Myths and Realities*, group exhibition, Museum of Fine Arts, Houston,
 1995; *Martin Luther King Civil Rights Movement*, group exhibition, Museum of Fine Arts, Houston, 1991.
Co-founder of FotoFest in Houston, Texas.

Wendy Watriss
Born February 15, 1943, in San Francisco.
Lives in Houston, Texas.
Education: BA, English Literature, New York University, 1963–65; University of Madrid, Spanish, 1962.
Selected recent exhibitions: National Museum of Women in the Arts, solo exhibition, Washington, D.C.,
 1993.
Selected honors, awards, grants: The NEH/NEA Mid-Atlantic Arts Alliance, Rockefeller Foundation.
Co-founder of FotoFest in Houston, Texas.

During the two years we spent in Grimes County (including prior and subsequent visits), we lived as close to our subjects as possible. Our domicile was a thirteen-foot trailer that was parked in the back pasture of a black farmer friend. We had an office and paid fifteen dollars a month rent in Anderson, the county seat (population 500 daytime, 50 nighttime). The office had a darkroom made out of plastic garbage bags to cover the places where the roof had caved in and a toilet that supplied water to the enlarging/developing area. This arrangement made it possible to become a free photographic service for the people of the county, and this service gave us surprising access to many people who might have been difficult to get to under different circumstances. Thousands of photographs were given away to our subjects.

Many of the guests at this country wedding in Grimes County were from Houston, and some of them were students at Prairie View A&M, a predominantly African-American university in an adjacent county. The reception was held in a community social center. Although some of the Grimes County men in these pictures were not strangers to Railroad Street, these young people would be more apt to do their socializing in Houston.

These two sets of pictures provide very different aspects of Saturday night life in rural Grimes County, an area that once had a cotton and corn plantation economy with a black population that was close to fifty percent.

–Wendy Watriss

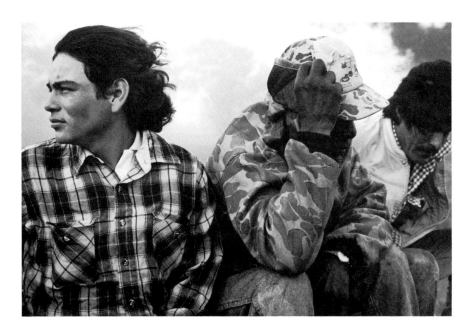

Jeff Whetstone

Eduardo, James, Arturo
(Meadow, North Carolina)
1992
Gelatin silver print
12 x 18

Bottom Prime (Four Oaks, North Carolina)
1992
Gelatin silver print
12 x 18

Born March 8, 1968, in Chattanooga, Tennessee.
Lives in Chattanooga, Tennessee.
Education: BS, Duke University.
Selected recent exhibitions: Kentucky Arts Council Awards exhibition, Louisville; juried exhibition, Fine Arts
 Museum of the South, Mobile, Alabama; Appalachian Festival, Cincinnati, Ohio.
Selected honors, awards, grants: Kentucky Arts Council, Al Smith Fellowship, 1994; Lyndhurst Foundation,
 Young Career Prize, 1991 and 1992.

The South I know thrives. There is plenty of rain and the growing season is long. Hot nights in August ripen things. The South I know is full of farmers. Farmers of miles of beans, allotments of tobacco, or just a few rows of corn.

There is a young man in Newton Grove, North Carolina, who will inherit his father's tobacco allotments. He thinks the future of tobacco is bleak, but he will stay on and grow something. "Maybe melons," he often says.

My photographs depict the bond between people and the farm. It is not a perfect union. Farming demands much of people—their sweat, their humility, and their devotion. Farming is inescapable for many. "In the blood," they say, to watch the seasons pass, the clouds approach, the new sprout break ground.

—Jeff Whetstone

Eduardo Orozco, James Johnson, Arturo Sanchez, and I were passengers in the back of a Dodge Prospector pickup truck at the very beginning of dawn. It was near the end of September; it had been the first cold night of autumn in the low country of North Carolina, and only a few acres of brightleaf tobacco remained standing in the fields. Barely two days after the last leaf was picked, racked, and put in the barn to dry, Eduardo and Arturo and their families were on their way back home to the Rio Grande Valley to wait for the citrus to ripen in Florida, or the apples in Virginia, or the cabbage in Michigan or to seed broccoli fields in Texas, prune peach trees in Georgia, or dig yams in South Carolina.

Perhaps a more defining photograph of Eduardo and Arturo could have been taken a few days later in the dark predawn hours after harvest was done: the family packing their Ford Escort station wagon, driving past fields of leafless tobacco stalks, turning south on Interstate 85, passing signs at state lines as familiar as the change of the seasons.

—Jeff Whetstone